The Tiger's Eye
 The Art of a Magazine

Pamela Franks

Yale University Art Gallery
 Distributed by Yale University Press
 New Haven and London

Published on the occasion of the exhibition
The Tiger's Eye: The Art of a Magazine,
at the Yale University Art Gallery
from January 29 through March 30, 2002

This exhibition and catalogue are supported
by the Florence B. Selden Endowment
and by donations from Mrs. John Stephan,
The David T. Langrock Foundation, Ms. Susan
Morse Hilles, and an anonymous donor.

Texts and page spreads are reprinted with
permission of *The Tiger's Eye*. An index
of contributors to *The Tiger's Eye* compiled
by John J. Stephan provided the starting point
for the annotated index published here.

Cover: *John Stephan, untitled painting
for the cover of *The Tiger's Eye*, Numbers 1
through 4, 1947, oil on canvas, 18 × 24
inches, collection John J. Stephan

Published by Yale University Art Gallery
www.yale.edu/artgallery

Distributed by Yale University Press
New Haven and London
www.yalebooks.com

Library of Congress Catalog Number: 2001097917
ISBN 0-300-09452-3

The Tiger's Eye was a journal of art and literature published in nine quarterly issues from 1947 to 1949.

Its diverse contents captured the creative ferment of these postwar years from the point of view of the artist-editors and their circle.

The Tiger's Eye:
Number 1, October 1947
Number 2, December 1947
Number 3, March 15, 1948
Number 4, June 15, 1948
Number 5, October 20, 1948
Number 6, December 15, 1948
Number 7, March 15, 1949
Number 8, June 15, 1949
Number 9, October 15, 1949

This book has been designed as an
homage to the original publication
without being a facsimile.

All works of art included in the
exhibition are illustrated in this
volume. An additional selection of
works that were published in the
original issues of *The Tiger's Eye* also
appear here. Asterisks precede
captions for works in the exhibition.
Issue and page numbers are cited
at the end of each caption.

Contents

Lenders

Addison Gallery of American Art, Phillips Academy,
Andover, Massachusetts

University of Michigan Museum of Art, Ann Arbor

Timothy Baum

Brooklyn Museum of Art, Brooklyn, New York

Antonio Frasconi, courtesy Ellen Sragow Gallery, New York

Drs. Marika and Thomas Herkovic

Diana and Duncan Johnson

William Mandel and Robert Russell

Beinecke Rare Book and Manuscript Library, Yale University,
New Haven, Connecticut

Grey Art Gallery and Study Center, New York University, New York

Kraushaar Galleries, New York

The Museum of Modern Art, New York

The Art Museum, Princeton University, Princeton, New Jersey

Lawrence Saphire

Mrs. John Stephan

John J. Stephan

Munson-Williams-Proctor Arts Institute, Museum of Art,
Utica, New York

National Gallery of Art, Washington, D.C.

Foreword

The convergence of factors that spurred this exhibition was so pronounced that I feel *The Tiger's Eye: The Art of a Magazine* was somehow destined to take place at the Yale University Art Gallery. My dear friend Maud Morgan, whose work was featured in *The Tiger's Eye*, Number 6 (1948), gave me her set of the nine magazines in 1997 on her ninety-fourth birthday. I was then still directing the Addison Gallery of American Art at Phillips Academy, Andover, where Morgan and her husband, Patrick, had both been extra-ordinary artist/teachers. I was fascinated by the publication; it was clear that the editors, poet Ruth Stephan and painter John Stephan, had accomplished truly exciting and formative work in collaboration with an extremely impressive group of artists and writers during the late 1940s. In 1998, not long after assuming the directorship of this institution, Richard Benson, the Dean of Yale's School of Art, asked me if I was familiar with the art of John Stephan because he wanted to introduce me to Mrs. Ineko Stephan, his good friend and neighbor in Newport, Rhode Island. Having studied my recently acquired set of *The Tiger's Eye*, I was happily able to say that yes, indeed I did know of the painter John Stephan and that I was eager to learn more. Shortly after, we visited Ineko Stephan and I was enthralled by the extensive effort she had made to catalogue and archive her late husband's paintings, drawings and papers. We were able to trace John Stephan's fascinating creative career by the range of work she showed us, and his files became a treasure trove of letters from family and friends, including some from artist friends such as Clyfford Still and Barnett Newman, both of whose work had been published in *The Tiger's Eye*.

Back in New Haven, Richard Benson serendipitously located a complete set of *The Tiger's Eye* for sale two days after our visit to Newport. Our current Florence B. Selden Fellow, Pamela Franks, had recently joined us at the Art Gallery, and I asked her to buy them for the collection. Once the magazines arrived, I noticed Ms. Franks pouring over them time and again. The Stephans' editorial project happened to coincide beautifully with her ongoing research on creative communities and artists' initiatives to show and distribute their own work. Not a week later, Ms. Franks discovered that the papers of both Ruth Stephan and *The Tiger's Eye* were part of the collection of the Beinecke Rare Book and Manuscript Library at Yale. With so much interest and so many resources coming together, it appeared impossible not to engage this rich cultural resource, and thereafter preparations began in earnest to produce an exhibition documenting this seminal artists' publication. The papers of *The Tiger's Eye* turned out to be forty-three boxes of unprocessed materials. The essay published here is thus a history of the magazine based on a remarkable cache of primary-source material.

The success of the exhibition, which aims to recreate some of the groupings and juxtapositions originally presented in *The Tiger's Eye* within the space of the gallery, ultimately depended on the generous cooperation of

the various institutions and private collections in which these particular works now reside. In every case, works of art borrowed for this exhibition are critical to demonstrating the vision of *The Tiger's Eye* and we are grateful to each and every lender for the enthusiastic response this project has received. Certain institutions should be singled out for their generous willingness to lend multiple works. The Museum of Modern Art, New York, has loaned a major painting by Rufino Tamayo as well as many important prints. The National Gallery of Art, Washington, D.C., very kindly has loaned five beautiful paintings by Mark Rothko, reproductions of which spanned the run of *The Tiger's Eye*. Four important paintings from the Addison Gallery of American Art greatly enhance the installation. The Brooklyn Museum of Art has loaned several prints that appeared in the pages of *The Tiger's Eye*. Thanks is also due to Timothy Baum, Antonio Frasconi, Drs. Marika and Thomas Herkovic, Diana and Duncan Johnson, William Mandel and Robert Russell, Lawrence Saphire, Mrs. John Stephan, and John J. Stephan who have fortified Ms. Franks' exhibition with generous loans from their personal collections.

The Florence B. Selden Endowment at the Yale Art Gallery makes possible a particular sort of educational endeavor that is central to the mission of this teaching museum. Not only will the rich historical and interdisciplinary content of this exhibition and publication be of interest to students of the School of Art, department of the history of art, and all of the university, so does the Selden Fellowship make it possible for a promising young scholar such as Pamela Franks to pursue in-depth research while simultaneously benefiting from on-the-job training in every aspect of organizing an exhibition and accompanying catalogue. As well as funding the Fellowship, of which Ms. Franks is the third recipient, the Selden Endowment provides the major funding for the fellow's exhibition and catalogue. I am also especially grateful for the additional financial support provided by Mrs. John Stephan, Ms. Susan Morse Hilles, and an anonymous donor who enabled the full ambition of Ms. Franks' intellectual and artistic inquiries to be shared in public. *The Tiger's Eye: The Art of a Magazine* marks the first time a project organized by the Selden Fellow has developed into a major Gallery exhibition, a privilege Ms. Franks earned on this basis of a worthy proposal backed up with sound research. She has demonstrated remarkable talents, energies, and thoughtfulness in seeing to every detail of this complex project, doing so in an always efficient and cheerful manner, one that has won her broad respect from all of her Gallery colleagues and the many other individuals and institutions who helped her bring this creative endeavor fully to life.

Jock Reynolds
The Henry J. Heinz II Director
Yale University Art Gallery

Acknowledgments

First and foremost I want to thank Jock Reynolds, who has been a most inspiring mentor and a constant source of insight and encouragement. With relentless energy and enthusiasm, he daily tests the limits of the possible, guiding the Yale University Art Gallery through an especially exciting time of exhibitions and programming. I am grateful to him for his guidance during the preparations for *The Tiger's Eye: The Art of a Magazine* and throughout my two years as Florence B. Selden Fellow. His vision as an artist and patience as a teacher are perfectly suited to the spirit of this project. *The Tiger's Eye* magazine came into being during the late 1940s as a result of artists' belief in the value of culture and the importance of reaching a broad audience. The current exhibition and catalogue result from a similar commitment to historical and aesthetic inquiry and dialogue fostered by Jock Reynolds's leadership at the Art Gallery.

Suzanne Boorsch, the curator of prints, drawings, and photographs, has been a constant source of intellectual inspiration and practical advice, and has tirelessly discussed the content of both the exhibition and the catalogue at every stage of the project. In a feat of heroic research and diligent attention to detail, Mariana Mogilevich, the Betsy and Frank H. Goodyear, Jr., B.A. 1966, undergraduate intern, has compiled and annotated an index of contributors to *The Tiger's Eye* that will open doors to much future research. She was also involved in every aspect of organizing this exhibition, and her input has been invaluable. Our colleagues in the department of prints, drawings and photographs, Lisa Hodermarsky, Russell Lord, and Diana Brownell have been consistent sources of historical, organizational, and technical expertise, not to mention excellent company. Diana Brownell deserves special recognition not only for allowing me to invade her workspace, but also for very generously insisting that I take the window spot.

Other colleagues from the Yale University Art Gallery have been critical to the success of this project. As conservator for the exhibition, Mark Aronson answered what I suspect may have been an unusually non-stop stream of questions with the utmost patience and attention to detail. Patricia Garland cleaned and restored a painted portrait of the magazine's literary editor by its art editor that is critical to the exhibition. The Art Gallery's registrars skillfully orchestrated the shipment and handling of all loans and purchases for the exhibition, and Lynne Addison deserves special recognition for generously sharing her expertise in this regard. The exhibition design was much improved through the careful eye and spatial sense of Clark Crolius, and I am grateful to him for his guidance in both the aesthetic and the technical aspects of the installation. The entire digital imaging crew is to be thanked for providing many of the excellent images for reproduction that appear in the catalogue and promotional materials. Mary Kordak, Ellen Alvord and everyone in the education department patiently listened to my

ideas in process at every stage of planning for the exhibition and have expertly tailored these raw ideas into exciting and feasible programming. Marie Weltzien impressively handled all publicity. She also cheerfully responded to each and every plea I made for editorial consultation, and her comments immensely improved the verbal presentation of this project on every front. Kathleen Derringer provided sage advice and moral support in the process of raising the needed funds. Jennifer Gross and Joanna Weber in the department of european and contemporary art were both eager to share their enthusiasm for twentieth-century art, and discussions with each of them have been sustaining. It has been a particular privilege to work in tandem with Jennifer Gross as we organize complementary exhibitions, and to collaborate with her on the Lydia Winston Malbin Lecture Series to bring several luminary speakers to the Art Gallery in conjunction with these exhibitions. I am indebted to Joanna Weber for sharing her experience and expertise in all aspects of project management, from budgets to scheduling. Howard el-Yasin is to be commended for seeing this book through the steps of publication. Louisa Cunningham, Charlene Senical, and everyone in the business office have attended to the overall budget and details of individual expenses with great efficiency.

In addition to Suzanne Boorsch's repeated readings of various drafts of the catalogue text, Mark Aronson, Lori Cavagnaro, Christine Mehring, and Mariana Mogilevich all commented carefully on the essay, and their insights were immeasurably helpful. Elizabeth Franzen applied her expert editing skills every step of the way, and she was essential to finalizing all catalogue text, both for her editorial expertise and her excellent sense of humor. Staff members at the Beinecke Rare Book and Manuscript Library, and above all Patricia Willis, Elizabeth Wakeman Dwight Curator, Collection of American Literature, were immensely helpful in my research of the papers of *The Tiger's Eye* housed in that collection. Similarly, the staff of the Art and Architecture Library of Yale University frequently (and cheerfully) went above and beyond the call of duty. To say that Nathan Garland expertly designed the catalogue would be an extreme understatement of his contribution. He immersed himself in the vision of *The Tiger's Eye* and has produced a book that truly lives up to the ideals espoused by the publication it honors. He has also been an unusually attentive listener and insightful commenter on ideas pertaining to all aspects of this project, and in addition an incredibly generous teacher regarding matters of book design.

The exhibition would not have been possible without the participation of the extended family of *The Tiger's Eye*. John J. Stephan, the son of *Tiger's Eye* publishers Ruth and John Stephan, has very generously supported this project in a multitude of ways, answering endless research questions, organizing conservation work, photography, and framing for several key works that he

has agreed to lend to the exhibition. The exhibition and catalogue would truly have been impossible without his enthusiastic support. I am especially grateful to Ineko Stephan, the widow of John Stephan, again without whom this project would not have happened. Her generous spirit cannot be captured in words, but it may at least be indicated by noting her participation through lending important works from her collection to the exhibition, sharing her impeccably organized archive of primary source material on John Stephan and *The Tiger's Eye*, her warmth and generosity in bringing people together in support of this exhibition, and for all the delicious Japanese cuisine that appeared whenever it was time to take a break from the files. Ineko Stephan's friendship has been an unexpected and especially fortunate benefit of working on this project.

Several collectors have generously agreed to lend works that are essential to the exhibition, including Timothy Baum, Antonio Frasconi, Drs. Marika and Thomas Herskovic, Diana and Duncan Johnson, William Mandel and Robert Russell, and Lawrence Saphire. Among the individuals at lending institutions who deserve special attention are Allison Kemmerer and Denise Johnson at the Addison Gallery of American Art, Annette Dixon and Lori Mott at the University of Michigan Museum of Art, Marilyn Kushner and Rachel Danzing at the Brooklyn Museum of Art, Michelle Wong at the Grey Art Gallery, Carole Pesner at Kraushaar Galleries, Jennifer Roberts at the Museum of Modern Art, Maggie Mazzullo at Munson-Williams-Proctor Arts Institute, Museum of Art, and Jessica Stewart and Allison Langley at the National Gallery of Art.

<div style="text-align:right">

Pamela Franks
The Florence B. Selden Fellow
Yale University Art Gallery

</div>

Language is a primary abstraction that continually is being taken for granted as if it had "just growed" like Topsy or like grass. Actually the dictionary is the great history of man's belief and of the reality he has created. Words such as *window*, *fire-tongs*, *gun*, *coat* show inventions he considered necessary, while others such as *oblige*, *botany*, *run*, *sequence*, *early* express his choice of what is meaningful. To look at them objectively is to marvel, for each word is proof of a mutual decision.

If we limit ourselves to a conception of language as a written medium, however, we will be unable to understand the Incas and many tribes that compose the Andean civilization, or other races that, like them, have not used the written word as we know it. Yet the Andeans performed feats of craftsmanship and engineering, social and political adjustments, aesthetic and poetic sensibilities which not only have modern counterparts but even appear to answer more purely our contemporary attempts. They had no hesitation in accepting writing from the Spaniards to put down some of their remarkable theater pieces and fictions but they made little or no effort to preserve it or to develop it as a facet of their history.

As we look at their art—at its diverse spontaneity, its ease in humor, its imaginative elasticity—we must realize that a sentence is not the only packmule for an idea. It is in the realm of the pictorial where language can find new expressions of reality.

—Editorial Statement, *The Tiger's Eye*, Number 5, October 20, 1948, page 73

Looking Through *The Tiger's Eye*

If, as the editors of *The Tiger's Eye* assert here, the dictionary can function as "the great history of man's belief and of the reality he has created," so does their magazine itself offer a history, though one more circumscribed in time and focus. *The Tiger's Eye,* a magazine of art and literature published by poet Ruth Stephan and painter John Stephan, appeared in nine quarterly issues from October 1947 to October 1949. The dictionary has, in its plethora of words, all the raw stuff of the history it contains. It is equally replete with evidence of the values embedded in language, and this evidence can be more or less visible depending on the angle of viewing. Note, for example, how taking notions of the necessary and the meaningful into consideration enhances the significance of the words singled out. *The Tiger's Eye,* itself a "packmule" for the art and ideas of its time, bears the stuff of its history. And like the dictionary, it can illuminate value systems that lent meaning to the culture it documented.

The editorial philosophy of *The Tiger's Eye* was defined by its openness. Ann Eden Gibson's groundbreaking consideration of artist-run publications clearly demonstrates that while *The Tiger's Eye* was an important vehicle for early Abstract Expressionist images and ideas, the magazine was strongly committed "not to make a paradigm."[1] The Stephans published work by known and unknown contributors alike, without regard for preexisting stylistic hierarchies, and though the majority of works published were from the twentieth century and often only very recently completed, older work was periodically included. In the case of both historical and contemporary art, the Stephans actively sought work from their immediate communities and from around the world.[2] The examples of traditional Peruvian art forms featured in this special issue devoted to "The Andes" were thus a direct result of the magazine's actively inclusive editorial policy. The editors' response as they described it here outlined the sort of creative confrontation they wanted the magazine to spur in its readers: "As we look at their art"—the emphasis on process is not gratuitous—"we must realize"—meaning came into being through the looking. *The Tiger's Eye* approached meaning as constructed and historical rather than natural or "just growed," a product of both creation and reception, and ultimately a matter of "mutual decision."

The late 1940s were years of diversity and cross-pollination with artists of many nationalities working in different styles and mediums often in dialogue with each other. Gibson cites sculptor Peter Grippe's recollection that art editor "John Stephan had an idealistic desire to tell it just as it is [. . .] to go out and support existing movements no matter how diverse they were."[3] It was never a matter, however, of diversity for diversity's sake, and *The Tiger's Eye* was not simply "supporting" existing movements, but rather actively engaging in the current dialogue. Gibson also cites Robert Motherwell's observation that Stephan's tendency to ask other artists for their opinions and advice made *The Tiger's Eye* "the only magazine that was a collaboration of all the artists."[4] The collaboration went beyond immediate day-to-day contacts with artists in New York. When John Stephan wanted to reproduce Pablo Picasso's painting *Three Dancers* (1925) in color, which

Robert Motherwell,
The Red Skirt, 1947.
Oil on composition board,
48 × 24 in. Collection
of Whitney Museum of
American Art, Purchase
(*The Tiger's Eye* 3:95)

meant it would have to be sent across Manhattan from the Museum of Modern Art where it was on loan from the artist, to the engraving company downtown, the museum naturally declined permission. Stephan then contacted Picasso directly, and Picasso agreed to the reproduction, forcing the museum to deviate from their normal standards of care, but ensuring that a color reproduction of the painting would be available to all readers of *The Tiger's Eye*, Number 3. As this exchange with Picasso suggests, connections among artists were part and parcel of *The Tiger's Eye*, often in spite of geographical distance and varying degrees of recognition.[5]

In the wake of the overwhelming destruction of World War II, the direction of art and even the very possibility of meaningful creative work were open to question. At the same time, the postwar moment, perhaps paradoxically, allowed for an idealistic internationalism and an optimistic faith that open dialogue among artists and the art public could be productive, and that aesthetic value transcending medium and cultural and historical context could be possible. These beliefs were ultimately the foundation of *The Tiger's Eye*'s editorial philosophy, as well as the motivating force for confronting the questions of their time.

The dictionary can indeed be approached as a history, and since language is a fundamentally defining aspect of humankind, the ambitious notion of the dictionary as a history of all belief and reality is conceivable. The dictionary is also, and more familiarly, a tool. It is useful for finding meanings, spellings, and etymologies, and ultimately it is this real use value that makes it credible as a repository of history. Like the dictionary, the magazine was created not as a history, but rather as a tool. It provided a means of bringing together and circulating the diverse art and ideas of its time, and in doing so, facilitated the dialogue that moved culture through this postwar moment of crisis. In hindsight, it is clear that *The Tiger's Eye* was the product of a period of profound transition. Styles of the European modern tradition gave way to a new American abstraction, and the center of the art world, already displaced from Paris during the war, shifted in a more permanent way to New York. The short run of the magazine, though certainly not intentional on the part of the editors, only heightens its historically specific effect.

Like language, art can be seen as fundamental to human life, and indeed *The Tiger's Eye* partook of this belief. The present project, however, maintains a more circumscribed focus, considering *The Tiger's Eye* as both product and producer of the beliefs current among the creative communities of its time, and as both reflector and facilitator of the reality the agents of those communities created. Looking through *The Tiger's Eye* can be like looking through a window into the art world of the late 1940s, offering a period view from the perspective of artists living and working within the very creative communities they documented.

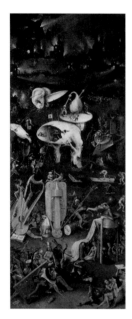

Hieronymous Bosch, *Hell,* right panel from triptych, *The Garden of Earthly Delights,* ca. 1504. Oil on panel, 86 ⁵/₈ × 38 ³/₁₆ in. Museo Nacional del Prado, Madrid (*The Tiger's Eye* 9:60)

The Intention of *The Tiger's Eye* is to be a bearer of ideas and art. In the belief art is a quest that can be good only as water is good, there is no wish to reach for a halo of *GOOD*, which is a prudish proud ambition. It places its dependence, instead, on ingenuous and ingenious artists and writers, whoever and wherever they are, as they move through the dimensions of curiosity.

Because each piece is chosen for its own sake and always should be approached as such, regardless of who designed or wrote it, the names of contributors will be printed separately in the center of the magazine. All literature will appear as it was written, for grammar and style are among the pleasures and responsibilities of the author. The selection of material will be based on these questions. Is it alive? Is it valid as art? How brave is its originality? How does it enter the imagination?

Now *The Tiger's Eye* is ready to observe, not criticize, as it journeys through the Dusk of Fantasy and the Morning of Reality.

—Editorial Statement, *The Tiger's Eye*, Number 1, October 1947, page 53

The inaugural issue of *The Tiger's Eye* appeared in October 1947 after several months of intense planning and work. When Ruth and John Stephan first discussed the idea of starting a journal sometime during the summer of 1946,[6] the little magazine was already a genre with an established tradition. Essentially a twentieth-century form, there were more than six hundred different little magazines published in English over the decades preceding *The Tiger's Eye*.[7] These publications generally operated as noncommercial ventures, maintained a commitment to experimental content, and catered to a small audience of intellectuals. In most cases, circulation was not more than one thousand and was often lower.[8] When starting *The Tiger's Eye*, Ruth and John Stephan made use of established conventions of the little magazine trade, but the realization of the magazine, and certainly its particular character, ultimately depended on the interests, skills, and connections they had developed separately and together over many years.

Ruth and John Stephan married in Chicago in 1939. Believing that the most lively art and poetry were to be found in New York City, they moved east in November 1941. The Stephans decided to settle in Westport, Connecticut, because of its proximity to New York and high concentration of writers and artists.[9] From Westport, they made regular trips into the city, frequenting galleries and exhibition openings. Early on, they met art dealer Pierre Matisse and sculptor Ossip Zadkine; it was through these two friends that the Stephans met many other Europeans who had come to New York to escape World War II. They socialized with artists from Surrealist circles, many of whom would later contribute to *The Tiger's Eye*, including Max Ernst, Yves Tanguy, Matta, and Kurt Seligmann, among others.[10]

Zadkine also introduced the Stephans to the fledgling art dealer Betty Parsons.[11] John Stephan's first solo exhibition in New York was at the Argent Galleries in 1944,[12] and while this exhibition featured paintings, Stephan had primarily been working in mosaic since the mid-1930s, initially under the auspices of the WPA. Parsons curated an exhibition of Stephan's mosaics for the Mortimer Brandt Gallery in 1945.[13] Shortly after, Parsons took over Mortimer Brandt's space, transforming it into an open, bright-white environment conducive to showing the increasingly large-scale and abstract work of young American artists in New York, many of whose work would later appear in *The Tiger's Eye*.[14] In early fall 1947, Stephan had his first of several solo exhibitions of paintings at the Betty Parsons Gallery.[15]

During these same years, the Stephans made comparable connections among the literary avant-garde. They were friendly with Robert Lowell, Van Wyck Brooks, Herbert Cahoon, Victor Wolfgang von Hagen, and John Nerber, all of whom would contribute to, and in the case of Cahoon and Nerber, eventually become associate editors of *The Tiger's Eye*.[16] In 1945, part of Maya Deren's film *Ritual in Transfigured Time* (1946), featuring Anaïs Nin and Deren, as well as the Stephans' young son John, and with appearances by Ruth and John Stephan and Gore Vidal, among others, was filmed at Stone Legend, the Stephans' home in Westport.[17] The Stephan family spent the first months of 1946 in Peru, where Ruth Stephan's first book of poetry, *Prelude to Poetry*, was published at the urging of friends, including Peruvian novelist José Maria Arguedas and poet Emilio Westphalen,

Facing page:

The Tiger's Eye, Number 6, pages 90 and 91, showing Kurt Seligmann, *Dream Factory*, ca. 1948 (left) and *The Devil and the Fool*, ca. 1948 (right)

The Tiger's Eye, Number 9, pages 66 and 67, with *The Hollow of Night* by Kurt Seligmann, illustrated with details from Hieronymous Bosch, *The Garden of Earthly Delights*

And similarly do Geiler and Brant stigmatize worldly music. The bagpipe so proudly worn by the *Fool-Monster, "signifies the world"* with all its enticements. "There is nothing but wind and emptyness, though the bagpipe's noise is so strong that one cannot hear the commandments of God but indulges in earthly pleasures, the punishment of which is eternal damnation."

Originally all musical instruments served the Good. Inspired by an orchestra of harps, flutes, drums, cornets, bagpipes, *Saul* used to prophecy. *Mary*, Moses' sister praised the Lord, accompanied by flutes, cornets, and drums. *David* played the harp when Saul had his frenzies, for the harp was — and still is — the instrument which the Devil cannot suffer.

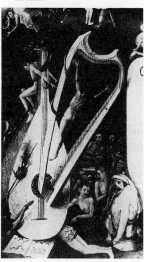

However, things changed gradually for the worse; man made evil use of the instruments. St. Cyprian rejected the flute which "is played with the fingers and the wind of the mouth, as if God had not given us a voice and tongue for his praise." Clement of Alexandria reports that lyres, guitars, and harps were played in church, "as did *Daniel* the prophet." And stringed instruments have kept their repute of purity, whereas concussion and wind instruments acquired an ambiguous character with the advance of culture and refinement.

Of the three simple Greek modes, *the Doric, the Phrygian and the Lydian,* only the Doric was suitable to church music, and it was played with stringed instruments.

The Phrygian was considered vicious, too easily inciting to anger or passion. Its instruments were horns, trumpets, bombards, drums, oboes, cornets, sackbuts, etc. The Lydian mode with its flutes and flageolets was thought to be effeminate, light, frivolous. Men were enticed by it to lust and lubricity.

In Bosch's satanic nocturne stringed instruments are present: a harp, a lute, and a hurdy-gurdy. *But they are mute!* Indeed, how could the strings of a harp sound when they pass through a human body? Nor does the lute emit sounds: its strings are held down at the sound hole by the harp with which it is strangely copulated. And the hurdy-gurdy cannot be played, if only by a giant strong enough to press down its enormous keys.

An aggressive *Phrygian*, and a vicious *Lydian* mode are played as one can recognize from the instruments, the gestures, and the facial expressions. The clown playing a flute with his anus is certainly a "Lydian," and the warrior-demon blowing his horn with might and anger, a "Phrygian." Anger and lubricity are the leitmotivs of the infernal concert, in full accord with the violent gamblers of the foreground and the obscene worshippers of Belphegor.

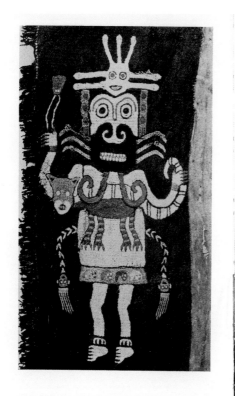

78

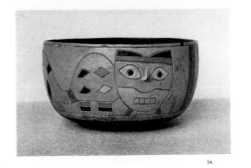

79

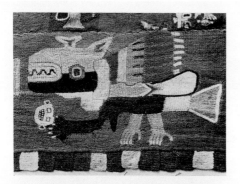

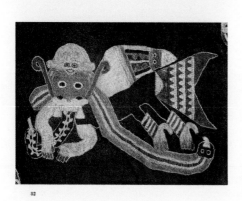

82

83

16

Facing page:

The Tiger's Eye, Number 5, pages 78 and 79, showing Paracas fabric, gold anthropomorphic figure, and Paracas bowl.

The Tiger's Eye, Number 5, pages 82 and 83, showing Paracas fabrics and painted border of a Paracas mantle.

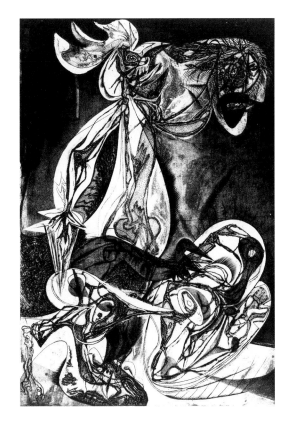

This page:

*André Racz, *Perseus Beheading Medusa IV*, 1945. Engraving and soft-ground etching on zinc, plate: 21 9/16 × 14 13/16 in. The Museum of Modern Art, New York, Spaeth Foundation (*The Tiger's Eye* 3:18)

*Bernard Reder, *Giant Escaping Earth*, 1948. Woodcut, 11 1/4 × 14 1/2 in. Brooklyn Museum of Art, Dick S. Ramsay Fund (*The Tiger's Eye* 8:37)

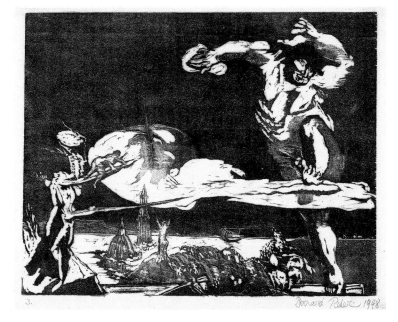

both of whom were later published in *The Tiger's Eye.*[18]

After returning to the United States that spring, Ruth Stephan met Surrealist writer Nicholas Calas at a social gathering and they discussed the possibility of starting a little magazine. In the days following, Calas informed Stephan that he would need to see a book of her poems before he could decide whether to join her in such an enterprise. Stephan was offended by what she took to be his superior attitude, and decided not to proceed with the collaboration. John Stephan then suggested that they could publish a magazine themselves, and preparations began. Calas, having heard of their intention to proceed on their own, cautioned: "It occurs to me that if you expect to use any of the ideas suggested to you by my wife or by me I feel that we should be consulted in advance to secure our permission."[19]

Artist and writer friends suddenly became a ready-made community of contributors and readers. Even Calas, despite his defensive tone at this early stage, eventually contributed to *The Tiger's Eye.* The aborted collaboration with Calas suggests the challenges and benefits of such a strong group dynamic. Dialogue developed out of the need for a community of like minds in a changing, postwar world. Community, in turn, cultivated dialogue that yielded ideas such as this one for *The Tiger's Eye.* It could also, however, be a hotbed of tension, and all the more heated among creative workers who must often have felt protective of their ideas and their work. Indeed, exactly who thought of what first must frequently have been less than crystal clear in a world where ideas were born of casual cocktail party conversation.

Ruth and John Stephan thus embarked on the magazine without outside editorial collaboration. It was very much their project: on Christmas Day 1946, Ruth Walgreen Stephan, the only child of drugstore magnate Charles Walgreen, and heir to a considerable family fortune, wrote John Stephan a check for the purpose of starting their magazine.[20] They did take on some practical help, employing Emeline K. Paige as business manager, and other part-time and temporary help. One such employee, Mary Francis Greene, conducted preliminary research into running a little magazine. A notebook kept during the summer of 1947 documents challenges faced from the outset. Notebook entries for "contributions," "private art collections," "poetry books," "distribution," "little magazine advertisers," "tiger material," "engravers," and "phones" suggest how varied the publishers' concerns had to be, ranging from the very identity and purpose of the magazine to the practical concerns necessary for keeping any periodical in print to the most mundane aspects of running an office.[21]

The meaningful and the mundane were entwined at every level. Ruth Stephan came up with the magazine's title, inspired by William Blake's poem "The Tyger" (1794). The notion of the fierce life force looking out through the darkness was a powerful image for the magazine. As in Blake's poem, where creativity exists as a desirous driving energy in the midst of the indiscernibly thick darkness, the editors' ideals had to burn through the potentially obscuring deluge of real-world concerns. Such was the case in naming the magazine: preliminary research included substantial attention to other meanings the tiger reference might lend. An ongoing list of cultural references included the tiger in William Butler Yeats's "The Second Coming" (1903);

Tyger, tyger burning bright / In the forest of the night / What immortal hand or eye / Could frame thy fearful symmetry?

18

several paintings such as Paul Cézanne's *Le Tigre* (1873), Henri Rousseau's *The Jungle: Tiger Attacking a Buffalo* (1908), Eugène Delacroix's *Tiger Drinking* (1853); and a "tiger's eye" stone from the Minerology Department of the Museum of Natural History, Philadelphia. While resonant parallels such as these increase the potential for multilayered meanings and make the magazine's title all the more rich, other overlaps were potentially less desirable. A cautious survey of trade names including the word tiger turned up several businesses in the New York City area with which the editors did not want their magazine confused, for example, Manhattan's Tiger Skin Rubber, or Tiger Appetizing and Nut Shop in the Bronx.

Preliminary legwork regarding advertising and distribution necessitated the same mixed attention to messages being sent and pragmatic concerns. The upstart magazine had to advertise itself to create a demand. It also had to sell advertising space as an important source of revenue. But the editors were perfectly aware that advertising was treacherous ground, and the magazine's advertising rate card explicitly stated "*The Tiger's Eye* will not accept advertising unsuitable to its character." Preparatory research included an April 1947 survey of little magazine advertisers, itemizing the businesses that placed advertisements in a variety of comparable magazines. Publishers, bookstores, galleries, and other little magazines were the most frequent advertisers, and businesses tended to place ads in more than one magazine simultaneously. *The Tiger's Eye* editors considered advertising in *Art Digest, Art News, Critique, Furioso, Partisan Review, Poetry, Quarterly Review, View,* and several other similar publications. Placing advertisements in art and literary magazines was a straightforward attempt to reach an interested audience. It was also, however, a strategy for fitting *The Tiger's Eye* into the existing field by acknowledging the major players, so that, for example, an advertisement for *The Tiger's Eye* in the pages of *Partisan Review* or *View,* might suggest an affinity between the new magazine and the more established avant-garde venue, thus lending *The Tiger's Eye* credibility as well as publicity.

Similarly, early consideration of distribution strategies comingled the everyday pragmatics of getting the magazine out and available to interested readers and the more symbolic importance of keeping good company. Prior to hiring distributor J. M. Blanke, the editors decided that the fact that he distributed only in Manhattan was not a disadvantage, since Manhattan was the principle circulation area for existing little magazines whose audiences the new magazine hoped to tap. It was a matter of consequence for *The Tiger's Eye* to learn that "there [were] one hundred dealers for *Partisan* [*Review*] in the midtown section alone."[22] Unlike commercial magazine distributors who required a minimum number of copies beyond *The Tiger's Eye*'s entire print run, Blanke specialized in little magazines and was willing to manage any amount. A list of other periodicals handled, including the same big names in little magazines, functioned as a reference for the distributor's intellectual and ideological credibility, but above all addressed the pragmatic concern that *The Tiger's Eye* end up available to readers in the same bookstores as these other journals.

If the pen is mightier than the sword, it is only because it is wielded as a pen. Its thrusts do not kill outright, its adroitness sometimes liberates, and its impact allows reaction and reflection. If it were not for this bit of fortune, Art would be an elegiac memory, for the critic who wields it as a sword permits himself to become a counterpart of the lawmaker, the jailer, the executioner. He might be astonished if he were to visualize the uninspiring static position he has acquired.

And what does the artist think of the critic who examines him so freely? Some like Tamayo whose painting for critics is a woman thumbing her nose, think they are irrelevant. Some, like W. H. Auden, see a specific critic, Kenneth Burke, as a brilliant and provocative aide. Some, like John Nerber in his poetic comment on *The Critical Kingdom,* say:

> *Nothing casts nothing up to mind:*
> *Kind casts gravel at like-kind:*
> *The brave sheep bites the thornless rose,*
> *The nostril wets its own sharp nose.*
>
> *Throat cries hush to silent throat,*
> *Earth would on the water float.*
> *The Eye sees mirrors everywhere*
> *Reflecting beams that curse the air.*
>
> *The nets seine deep and the empty tide*
> *For birds which in the current ride,*
> *While overhead there swims the swan*
> *That in another age had sung.*

The critic, if he is to be respected, must prove his value as a wise observer. He must have the perspicacity to see that Art is greater than any of its talkers, and that in attacking it he is negating his *raison d'etre.* He must have the courage to project himself alongside the artist in new propensities, recognizing that newness is not pursued for its own sake, but that there still is something to be found.

—Editorial Statement, *The Tiger's Eye,* Number 3, March 15, 1948, page 75

Editorial
Observations

Rufino Tamayo, *The Joker*,
1946. Oil on canvas,
23 ¼ × 20 ⁹/₁₆ in.
Location unknown
(*The Tiger's Eye* 1:65)

*Anne Ryan, *Amazon*,
1945. Color woodcut,
7 ½ × 3 ¼ in.
Courtesy Kraushaar
Galleries, New York
(*The Tiger's Eye* 8:39)

The prospectus circulated before the first issue of *The Tiger's Eye* announced the magazine's rejection of "conventions such as book and art reviews." Positioning themselves as observers rather than critics, the editors proclaimed that "*The Tiger's Eye* is on—the lively, the curious, the imaginative in human and inhuman reality—it is on the character of genius and the strange adventures of Everyman awake in the world."[23] Paintings by Rufino Tamayo were reproduced in the first issue of *The Tiger's Eye* accompanied by no critical commentary, which, as the editors noted, Tamayo deemed irrelevant. They were simply described as "like framed instances of the particular wealth of his temperament."[24] The editors were especially pleased to include one painting that had never been exhibited,[25] and to have solicited Tamayo's commentary, written specifically for this volume and published in both the original Spanish and English translation.

Describing their role figuratively as that of observing along the journey, the editors also made literal expeditions for content. In the summer of 1948, a local newspaper reported "Mr. and Mrs. John Stephan of Westport will sail next week for Paris to explore material for their magazine *The Tiger's Eye*."[26] A few months later, the Gotham Book Mart's newsletter noted that "*The Tiger's Eye* editors just returned from France and Spain with new material by Artaud, Queneau, Noel Devaulx, Prevert, et al."[27] Response to material brought back was enthusiastic; for example, writer Henry Miller commented on the "excellent translation of Artaud (on Van Gogh)," saying that he "never believed it would appear in English."[28]

Such expeditions were an integral part of the Stephans' editorial process. *The Tiger's Eye*, Number 5, devoted to "The Andes," included images of traditional Peruvian textiles, ceramic vessels, and stonework, as well as a selection of translations of Andean Indian songs, ancient legends, contemporary essays, short fiction, and poetry in response to Andean culture. Replying to a letter complementing this extraordinary issue of *The Tiger's Eye*, Ruth Stephan explained: "Most of the Andean literature we brought back ourselves from Peru two years ago, so we feel very close to it."[29]

More local forays were equally fruitful. *The Tiger's Eye*, Number 8 featured a special section devoted to the graphic arts edited in collaboration with Stanley William Hayter.[30] Twenty-three prints were reproduced, eleven artists wrote statements, as did Una E. Johnson, curator of contemporary prints at the Brooklyn Museum, and a 1913 essay on lithography by Odilon Redon appeared in translation. Of the prints reproduced, some were by artists such as Ezio Martinelli (page 53), André Racz (page 17), and Anne Ryan, who worked at Hayter's Atelier 17 in New York, itself an important gathering place for artists during the mid to late 1940s.[31] Other artists made their way into the pages of this issue through connections to Hayter, though not specifically through working at his studio in New York. For example, an engraving by Hayter's friend and mentor, the Polish artist Joseph Hecht was reproduced. Hecht had introduced Hayter to the technique of copper engraving when Hayter worked in his workshop in Paris during the late 1920s (page 27).[32]

In other cases trips to galleries yielded discoveries. After Marion Willard had shown John Stephan examples of Louis Schanker's woodcut prints,

*Jean Dubuffet,
Sophisticated Lady (plate
XXI) from *Matière et
mémoire ou les lithographies
à l'école,* by Francis Ponge,
1944–45. Lithograph,
composition (irreg.):
10 $^{11}/_{16}$ × 7 $^{3}/_{8}$ in.; page
(irreg.): 12 $^{13}/_{16}$ × 9 $^{15}/_{16}$ in.
The Museum of Modern
Art, New York. The
Louis E. Stern Collection
(*The Tiger's Eye* 8:32)

*Odilon Redon, … *une
femme revêtue de Soleil,* from
the portfolio *L'Apocalypse de
Saint Jean,* 1899. Published
by Ambroise Vollard,
Paris. Lithograph and chine
collé, composition: 11 $^{3}/_{8}$ ×
9 in.; sheet: 22 $^{3}/_{16}$ ×
16 $^{3}/_{4}$ in. The Museum of
Modern Art, New York.
Gift of the Ian Woodner
Family Collection
(*The Tiger's Eye* 8:25)

*Pablo Picasso, *Portrait of
Vollard,* 1937. Aquatint,
plate: 13 $^{1}/_{2}$ × 9 $^{1}/_{2}$ in.;
sheet: 17 $^{1}/_{4}$ × 13 $^{1}/_{4}$ in.
Yale University Art Gallery,
Purchase for the Edward
B. Greene Collection
of Portrait Engravings
(*The Tiger's Eye* 8:35)

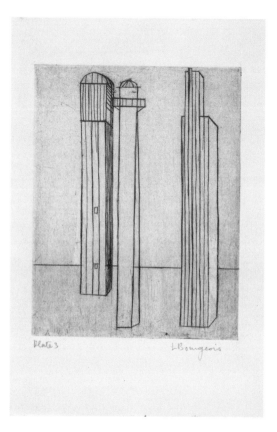

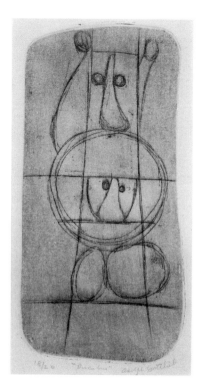

*Louise Bourgeois,
*Once a man was telling
a story, it was a very
good story too, and it
made him very happy,
but he told it so fast
nobody understood it,*

from the portfolio
*He disappeared into
complete silence*, 1947.
Engraving, plate:
6 ¾ × 5 ⁷⁄₁₆ in.; sheet:
10 × 7 in. Beinecke
Rare Book and
Manuscript Library,
Yale University
(*The Tiger's Eye* 7:91)

*Adolph Gottlieb,
Incubus, ca. 1946.
Etching, 9 ³⁄₈ × 4 ¾ in.
Yale University
Art Gallery,
Everett V. Meeks,
B.A. 1901, Fund
(*The Tiger's Eye* 8:28)

Facing page:

*Kurt Schwitters,
Merzmappe, 1923.
Lithograph,
21 ¹⁵⁄₁₆ × 17 ⁷⁄₁₆ in. Yale
University Art Gallery,
Gift from the Estate
of Katherine S. Dreier
(*The Tiger's Eye* 8:29)

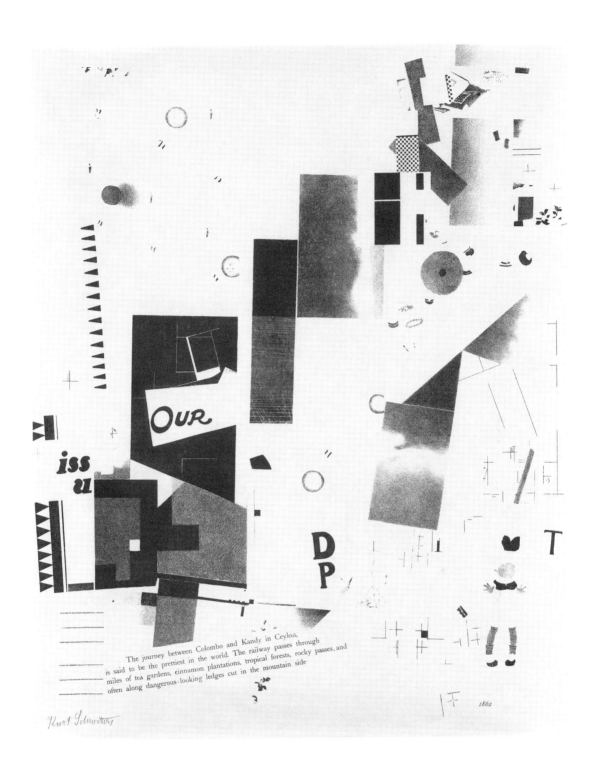

OUR

iss u

D
P

T

The journey between Colombo and Kandy in Ceylon, is said to be the prettiest in the world. The railway passes through miles of tea gardens, cinnamon plantations, tropical forests, rocky passes, and often along dangerous-looking ledges cut in the mountain side

1862

Kurt Schwitters

*Steve Wheeler,
The Power of Memory,
1947. Silkscreen,
10 ½ × 7 ½ in. Collection
of John J. Stephan
(*The Tiger's Eye* 8:19)

*Christian Rohlfs,
Prisoner, 1918. Woodcut,
composition and sheet:
24 ⅛ × 18 ⅛ in. The
Museum of Modern Art,
New York, Purchase
(*The Tiger's Eye* 8:30)

The Tiger's Eye, Number
8, pages 20 and 21,
showing Misch Kohn,
Bull Fight, 1949.
Wood engraving,
23 × 15 $^{1}/_{2}$ in. (left) and
Joseph Hecht, *Deluge*,
1926. Engraving, 9 $^{1}/_{2}$ ×
12 in. (right)

Stephan, hoping to include Schanker's work in issue eight, asked him to "write a page or two, more or less, from your personal experience, not so much technical as to methods [. . .] and let me have whatever photos of your work you would choose for reproduction" (page 60).[33] In the case of André Masson, whose essay "Color and the Lithographer" was published in the same issue, the gallery connection did not proceed so smoothly. Instead of providing *The Tiger's Eye* with an image of Masson's color lithograph *Hesperide* (1946, page 52), the gallery sent one of Masson's color aquatint illustrations for André Malraux's *Les Conquérants* (1947). In what must have been the extreme haste of production, *The Tiger's Eye* published the aquatint rather than the lithograph, which would have made much more sense with Masson's text. The next issue of *The Tiger's Eye* included a note that the published print had been mistitled.[34]

*André Masson, Illustration for *Les Conquérants* by André Malraux, 1947. Color aquatint, image: 12 7/16 × 9 1/8 in.; book: 15 × 11 in. Collection Lawrence Saphire (*The Tiger's Eye* 8:24)

In addition to galleries and Hayter's studio, public print collections in New York City also became sites of art-foraging missions. Prints were reproduced courtesy of the Museum of Modern Art, the Print Room of the New York Public Library, and the Brooklyn Museum. For the most part, the works reproduced from these museums were those of artists who did not live and work in New York, but who were significant enough to current thinking about printmaking not to be left out of the magazine's special section on the graphic arts. Odilon Redon presents an interesting case. A lithograph from the series *Apocalypse de Saint Jean, . . . une femme revêtue de Soleil* (1899) is reproduced (page 23). The editors most likely saw an impression of this print at the Museum of Modern Art. Ultimately, however, they chose to reproduce a later state of the lithograph from the collection of the New York Public Library. The deliberateness of this choice is emphasized by the fact that the Museum of Modern Art did have the earlier state in their collection,[35] and that Redon's print is the only one reproduced from the New York Public Library's collection. Redon's essay was influential specifically for its discussion of the color black. Statements such as "black is the most essential color" and "one must respect black," pervade the essay, and even these brief excerpts from Redon's complexly experiential text, suggest that the earlier, less black state of the print would not have done at all.

The Stephans' editorial observations merged with the regular routine of viewing art that was so much a part of their daily lives among artists. During this period, Ruth Stephan was a particularly close viewer of John Stephan's paintings.[36] When a group of these paintings was reproduced in *The Tiger's Eye*, Number 7, they were accompanied by Ruth Stephan's "A Response," introduced as "a first reaction to John Stephan's new paintings" (page 54). The Betty Parsons Gallery was a regular meeting and art viewing spot: when Barnett Newman sent his and Rothko's statements for Number 2, "The Attitudes of Ten Artists on their Art and Contemporaneousness," he included a note saying "Mark gave his to me late this afternoon after you and Ruth failed to come to Reinhardt's opening. We missed both of you."[37] Though they missed the opening, they would have had many opportunities to see Ad Reinhardt's work at Betty Parsons Gallery. John Stephan was first to buy a painting by Newman from Parsons's gallery, *Genesis—The Break* (1946), and he later reproduced it in the ninth issue of *The Tiger's Eye*. He

also purchased a painting by Clyfford Still around the time of that artist's first solo exhibitions in New York in the mid-1940s.[38] Ruth and John Stephan purchased Rothko's watercolor, *Personages* (ca. 1946), from Parsons in May 1947, just months before they reproduced it along with a group of his paintings in their first issue.[39]

The editorial emphasis on observation applied to Newman's brief tenure as associate art editor. John Stephan recalled asking Newman to come on board because "he knew more artists than I did [and] was always present at the [Betty Parsons Gallery] as a spokesman, a self-assumed spokesman."[40] In the mid-1940s, Newman was much more visible as a writer on art than as a painter, and this was equally true of his presence in *The Tiger's Eye.* Though three of his paintings were reproduced over the magazine's run, his written work was published five times, and he was on the editorial staff for Numbers 2 and 3. Indeed, Newman's first appearance in *The Tiger's Eye* was introduced with a text specifically portraying him as an astute viewer of art: "Barnett B. Newman, a painter and a spokesman for contemporary painting, who also has arranged exhibits of primitive art. He has been singled out by traditionalists as a man to watch (or to watch out for) because of his cognizance of changing forms in art."[41]

One of Newman's editorial contributions was the reproduction of a 1945 painting by Milton Avery in a special section devoted to "the sea" in Number 2. Titled *Man and the Sea* in *The Tiger's Eye*, elsewhere this painting is generally known as *Red Umbrella* (pages 31, 57). As Barbara Haskell has noted,

> Avery's approach opened new formal possibilities to American painting and exerted a profound influence on the group of younger artists whose work came to focus on the expressive potential of color. Both Rothko and Newman saw in Avery's disavowal of material paint deposits a way to make color evoke the sublime. Throughout the forties both artists continued to turn to Avery's work for inspiration; in 1946, despite their own lack of money, Annalee and Barnett Newman purchased one of Avery's paintings, *Red Umbrella*.[42]

Juxtaposed on the same page with a painting by René Magritte and grouped in this issue with other works on the sea theme, *Man and the Sea* might have looked different even to Newman, a viewer of Avery's painting over many years, and from 1946 forward, a viewer of this particular painting day in and day out.

Rejecting the convention of the exhibition review—and taking a cautiously suspicious approach to criticism in general—was a way of keeping the programmatic and the authoritarian at bay. "The critic, if he is to be respected, must prove his value as a wise observer," was the standard Ruth and John Stephan applied equally to themselves as editors. Rather than rejecting criticism outright, they instituted a policy that "any text on art will be handled as literature."[43] *The Tiger's Eye* thus remained open to the potential viability of criticism as a valid and lively form of thought. As if to demonstrate this point of view, Henry James's 1893 essay "Criticism" was reprinted in *The Tiger's Eye*, Number 1. In this context, James's text could be a description of *The Tiger's Eye*'s own deep commitment to observation:

And it is with the kinds of criticism exactly as it is with the kinds of art—the best kind, the only kind worth speaking of, is the kind that springs from the liveliest experience. There are a hundred labels and tickets, in all this matter, that have been pasted on from the outside and appear to exist for the convenience of passersby; but the critic who lives in the house, ranging through its innumerable chambers, knows nothing about the bills on the front. He only knows that the more impressions he has the more he is able to record, and that the more he is saturated, poor fellow, the more he can give out. His life, at this rate, is heroic, for it is immensely vicarious. He has to understand for others, to answer for them; he is always under arms. He knows that the whole honor of the matter, for him, besides the success in his own eyes, depends upon his being indefatigably supple, and that is a formidable order. Let me not speak, however, as if his work were a conscious grind, for the sense of effort is easily lost in the enthusiasm of curiosity.[44]

The editorial introduction to James's essay provocatively asked "is it not suitable today?"[45]

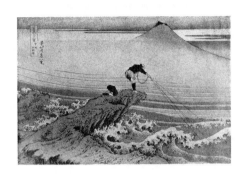

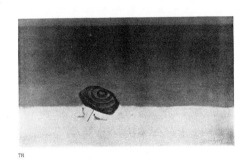

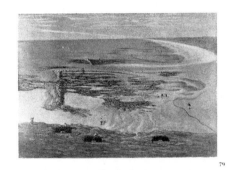

78

79

"ENGRAVING is the profession I was
apprenticed to"

wrote William Blake in a letter in 1799.
Now, in 1947, an experimenting poet and
two artists have rediscovered Blake's
unique printing method and are making
Illuminated Poems.

72

73

The Tiger's Eye, Number 1, pages 72 and 73. As introduced in Tale of the Contents: *Illuminated Poems. The plate of the fragment of Blake's America — A Prophecy is part of the Rosenwald Collection in the Library of Congress. It was etched in 1893 [sic] and, as far as is known, is the only surviving example of Blake's relief-etched plates. The Engraver has a design by S.W. Hayter, a Cornishman, famed for his experimental studio in Paris, where he lived for fourteen years. In 1940 he moved to New York and established a studio on Eighth Street. There the recent experiments with Blake's printing method were made.* (*The Tiger's Eye* 1:56)

The Tiger's Eye, Number 1, page 75. As introduced in Tale of the Contents: *The poems are by Ruthven Todd, a Scottish poet visiting in this country. He has published many books, poems, novels and essays, the latest one* Tracks in the Snow, *and is preparing a new book,* William Blake, The Mental Prince. *He has written a full account of Blake's method that will be published in a technical magazine. An Alien* World, *with a design by Joan Miró, was written by Todd for the painter's daughter. Miró, the richly imaginative Catalonian painter, is well known to the art world of Europe and the Americas. He is now in the United States where he continues his search in art for "new ways of expressing new things."* (*The Tiger's Eye* 1:56)

75

The surprising definition of machinery as "the agencies in the development of a plot, as of a poem, esp. supernatural agencies," given in Mr. Webster's dictionary, may be a leftover from a classic unmechanized era. Or it may be a reminder of the insistent nearsightedness of those who see machinery only as an assemblage of shafts, levers and wheels, and fear it as a Thing, a steel zombie, perhaps, able to dominate man's living and take precedence in his culture. It is this petrified viewpoint, which has been one of the pets of our age, that Art would depose.

When an artist cries "I am against machinery!" he means he is against this worshipful focussing on robot machines as if they were a triumphant point of life when they are just added evidence of the invention of man's imagination. Beyond their symbol of use, they should be discarded as an idea. Future generations will laugh at our awe of these implements.

Actually, the history of mankind is a developing plot. And when we remember that *supernatural* is that which is *beyond the observed sequences of nature* and is gradually being converted into *natural* as we learn how to observe, the value of the artist in the plot is apparent. He is not limited in his vision. There is no line between the natural and the supernatural for him and he presents them with equal enthusiasm, to solve or extend or express, according to his aesthetic philosophy, his humanism.

—Editorial Statement, *The Tiger's Eye*, Number 4, June 15, 1948, page 69

Artists as Observers

One hallmark of *The Tiger's Eye* was its concern with the creative process: art in the making was a major editorial focus. As Ruth Stephan explained more fully, as "an aesthetic magazine, publishing poetry, essays, fiction, drawings and reproductions of paintings, we are also interested in showing the paths artists and writers have used towards creation of their art."[46]

The Tiger's Eye frequently presented artists' ideas in proximity to images of their work to give a sense of the creative process. Number 4, devoted to sculpture, featured twenty-two objects by as many sculptors, reproduced one to a page, and accompanied by texts by fourteen of the artists. Giacometti's recollection poetically transports its reader to the sculptor's state of mind:

> A large figure seemed to me untrue and a small one intolerable, and then often they became so very small that with one touch from my knife they disappeared into dust. But head and figures only seemed true to me when only small.
>
> All this changed a little in 1945 through drawing.
>
> This led me to want to make larger figures, then to my surprise, they achieved a resemblance only when long and slender.[47]

The sculpture issue notably reproduced one group of paintings by Walter Murch, of carefully observed subjects from the mechanical and natural worlds (pages 37, 84). In the statement accompanying the images, Murch quirkily insists that a "painting should give the sensation of sound the instant one looks at it," and that "the object painted, by becoming in the hands of the artist, a paint-object must produce sounds that have nothing to do with the intention of the object itself."[48] Betty Parsons, who exhibited Murch's paintings in her gallery, recalled "Murch wasn't abstract in the sense that Pollock or Rothko was abstract. Anyone could see that [. . .] but he was abstract in a real way. He was abstract in space and he created a totally new and terrific universe. Not everyone could see abstraction that way."[49] *The Tiger's Eye* brought out the essential abstraction of Murch's process by pairing his text and images. Like much of the sculptural work reproduced in this issue, Murch's paintings display less of the process of "becoming in the hands of the artist" on their very surface than do some of the other, more visibly abstract paintings by American artists reproduced throughout the run of *The Tiger's Eye*.

In some cases a particular body of reproduced work seems almost to encapsulate the editors' theory of creativity. A group of three printed poems produced collaboratively by Stanley William Hayter, Joan Miró, and the British poet Ruthven Todd, who observed,

> They attempted to rediscover the methods used by William Blake in the production of his *Illuminated Books,* as they realized that the accounts given in the standard books were not practicible. The poems were written by the author in bituminous varnish upon paper prepared with gum-arabic and by the use of heat and damp were then transferred to copper plates. The artists made their designs directly on the plates in the same varnish and, after it was dry, the plate was bitten in a strong solution of nitric acid. Surface prints like those of Blake have been obtained from the plates, although the examples chosen for reproduction here have been printed intaglio, like an ordinary engraving. The color print by Miró shows the combination of intaglio black and color surface printing.[50]

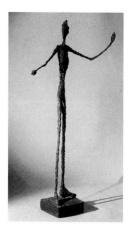

Alberto Giacometti, *Man Pointing*, 1947. Bronze, 70 1/16 × 37 3/8 × 20 1/2 in. Tate Gallery, London (*The Tiger's Eye* 4:85)

Facing page:

*Alberto Giacometti, Untitled, 1946–47. Graphite on paper, 23 1/4 × 17 7/8 in. Yale University Art Gallery, Gift of Molly and Water Bareiss, B.S. 1940s

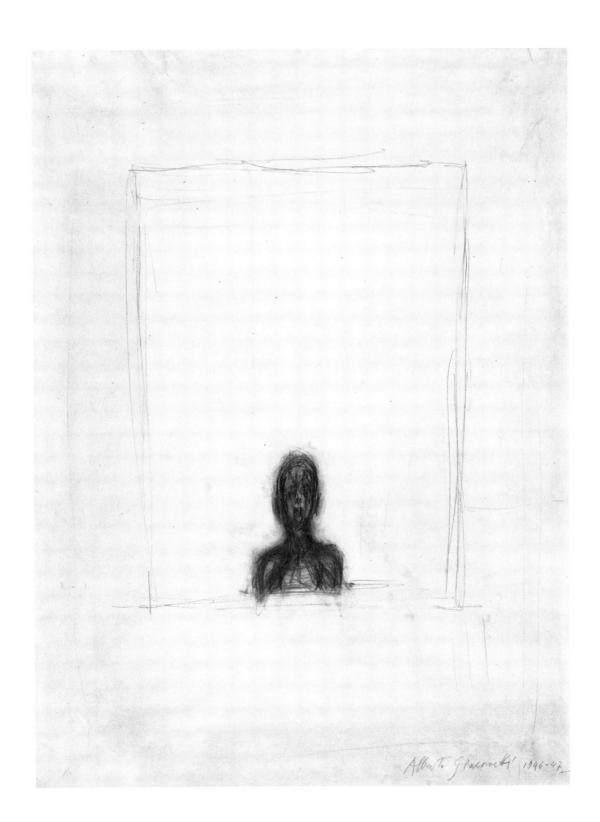

First page of a selection from Marianne Moore's reading diary and sketchbook (*The Tiger's Eye* 1:21)

Facing page:

The Tiger's Eye, Number 3, pages 106 and 107, showing Jackson Pollock, *Something of the Past*, 1946 (left) and Clyfford Still, Untitled painting, inadvertently reproduced upside-down (right)

The Tiger's Eye, Number 4, pages 42 and 43, with artist's statement (left) and Walter Murch, *Medieval Shape*, 1946 (right)

The artists not only collaborated with each other, they directly explored the historical precedent set by Blake. Print collector Lessing Rosenwald lent a fragment of a plate from Blake's *America a Prophecy* (1793) to these experimenting artists, and they printed from it.[51] Access to this plate fragment must have been particularly exciting because, as *The Tiger's Eye* noted, it was thought at the time that this fragment "as far as is known, is the only surviving example of Blake's relief-etched plates."[52] A group of experimental prints, including one from the fragment of Blake's plate, was reproduced in the first issue of *The Tiger's Eye*. The creative process of producing these prints hinged on engaging existing culture in a way that paralleled *The Tiger's Eye*'s own defining engagement with culture.

Another set of images, also published in the first issue, seem to demonstrate *The Tiger's Eye*'s view of creativity. Pages from Marianne Moore's notebooks, reproduced over fifteen pages under the title "Selections from a Poet's Reading Diary and Sketchbooks," lay out a creative process more about receiving than producing. As introduced in *The Tiger's Eye*:

> Marianne Moore began her reading diary in April, 1916, with an excerpt from the famous old magazine *Vanity Fair*, a prose poem by Baudelaire in English translation, "Anywhere Out of the World."
> The thousands of pages she has covered, since then, with notations from a diversity of magazines, books and newspapers has formed a miniature reference library of her interests. Any of her notebooks can be opened at random and perused with delight—with a delight, too, of the unexpected, for this was not a daily chore with a prearranged order, but a writing down of whatever she thought worthy of attention whenever she found it.[53]

Although Moore's poem "The Mind Is an Enchanting Thing" is printed here in the midst of the notebook pages, it is Moore the observer, recorder, processor that we are shown much more than Moore the creator. The delight of the unexpected, of gathering "whatever she thought worthy of attention wherever she found it," could equally well describe the editorial process of creating *The Tiger's Eye*.

One bit of promotional text indicates why creative process mattered so much to the editors: "The question of what culture is and how it is formed— whether through the insistence of geniuses or by the creative activity of groups or in the spontaneous expression of individuals—is a vital topic— for Art—is man's signature as a responsive being—it is his manifestation as a transformed animal."[54] In their view, creativity is the most fundamentally and fully human trait, the very locus of differentiation of human from animal. Creativity, as *The Tiger's Eye* explores, is a matter of making, but it is equally a matter of the creative work of receiving. Betty Parsons, writing after the first issue understood the implications of taking such a view: "I hardly know how to express in words my admiration for your introduction to *The Tiger's Eye*. It is so very fine—I hope all the artists live up to its wonderful challenge."[55]

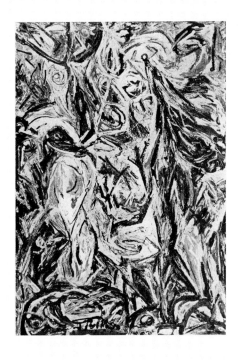

106

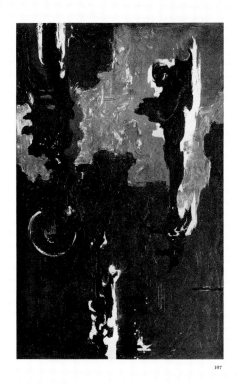

107

A painting should give the sensation of sound the instant one looks at it. To achieve this, the objects one paints cannot be left as objects, to sound like so many bells. They must be transformed into paint-objects that can carry their own instantaneous sound sensations, yet they must do so without any deliberate intent. The sensations one produces should be the resultant olfactions intended for an entirely different effect. When the priest in the high English service swings the incense to bless the audience, the actual instrument by which this is done makes a metallic, clinking sound of its own. So the object painted, by becoming in the hands of the artist, a paint-object must produce sounds that have nothing to do with the intention of the object itself. Only thus can the artist who is concerned with nature hope to achieve sounds capable of striking universal notes.

42

43

The first use of a name is for identification. A name is, also, an adjective, made by the life and work of a person. Consider the critical approach in reading the sentence *But it is vain to put wealth within the reach of him who will not stretch out his hand to take it* if it were signed by Al Capone, by Just Susan, by Karl Marx, by Chuang Tzu, or by its true author, Samuel Johnson.

The placing of a name with a statement adds force and meaning to the words, for the actuality of the person is the reason for reading the statement. A work of art is not a statement. It is a creation, a subtlety beyond direct description, with an entity of its own, and any intrusion of personality, even of the creator, is distracting. A work of art belongs, moreover, to whoever receives it within his life. This Hepplewhite chair is now *my* chair in *my* room. That Rilke poem is now *the reader's* poem in *the reader's* imagination. Why must he drag along the name and personal association of the poet? The artist who is not a self-adorist creates for the sake of creation, for the impulse to share the impact of reality or the sweep of fancy. Why should he try to build up an importance for himself? That is for the world to decide and to do.

Therefore, we use names as a recognition of merit, rather than as intellectual signatures, in *The Tiger's Eye*.

—Editorial Statement, *The Tiger's Eye*, Number 2, December 15, 1947, page 61

The Creative Work of Reception

If critics and editors are observers and creators are receivers, then what of the viewers and readers of the magazine whose role would normally be expected to be that of reception? Consider the following reader's response:

> The jerking away of the creator's name from the creation is certainly an imitation of God—but it's tough on the neophite seeking SOME thing to excuse his prejudices. I'm for you. You wanted to do it and you did it. Certainly I was at first irritated not to be able to find AT ONCE who wrote what. But I quickly recognized the advantages of your arrangement.
>
> What people resent most, of course, is that you show them up. Everyone instinctively looks to see the name first so that they may know how to feel. If the name is all right they can relax and enjoy without danger of committing a—clumsiness, to say the least. Without the name they would be lost. We are all a little that way.
>
> So it's a valuable thing to be forced back on one's self, one's own taste—or lack of it, so to gain actual and immediate sense contacts with the work of art. How many are up to that? Damned few.[56]

This was the reaction of poet William Carlos Williams to *The Tiger's Eye*, Number 3, published in March 1948, and, more specifically, to the magazine's most striking feature, its separation of authors' and artists' names from their work. Contributors were credited only in the table of contents, which was itself idiosyncratically located in the center of the magazine. Titled the "Tale of the Contents," this index annotated selected entries with biographical information about the contributor or observations on the work.

Looking through *The Tiger's Eye*, Number 3, readers such as Williams would encounter a typically broad range of contents. The diversity of this issue, reined in by a thematic focus on modern responses to classical culture presented under the title "Ivy on the Doric Column," was partly a result of the wide historical sweep of contents from ancient to contemporary. A poem, *To Aphrodite*, appears on the first page, and in the center of this issue the Tale of the Contents identifies its author as Sappho, asking, "Who, since the 7th century B.C., has surpassed Sappho's love lyrics?" Later in the issue and in keeping with the classical theme, Friedrich Nietzsche's *The Birth of Tragedy* (1872) is quoted. This nineteenth-century text is printed on the same page as a drawing that Theodoros Stamos completed within just months of its publication in this issue.

The classical theme provided an opportunity to bring together work by artists from different countries with little in common stylistically and to reproduce the work of more and less established artists side by side. The publication of Giorgio de Chirico's 1914 painting *The Endless Voyage* (page 128) circulated an image of one of his metaphysical, proto-Surrealist paintings on a page facing Robert Motherwell's 1947 painting, *The Red Skirt* (page 11). Both paintings depict figures to eerily dreamy effect, but de Chirico's painstakingly described system of pictures within pictures differs markedly from Motherwell's heavily brushed areas of red and yellow that cling insistently to the flat surface of the canvas. The similarity of the two paintings' emphatically vertical formats only enhances the contrast between the two artists' styles. Along more overtly Surrealist lines, Matta's *Onyx of Electra*

Page featuring quotation from Friedrich Nietzsche's *The Birth of Tragedy* (1872) and an untitled drawing, 1948, by Theodoros Stamos (*The Tiger's Eye* 3:79)

THE SUBLIME ISSUE *of* **The Tiger's Eye**

was shaped by the idea that sublimity is the visitor of many and not the exclusive guest of the rhetorical thinker or of religiosity · There is the importance, too, of finding new symbols, for medieval definitions have long been outmoded · What is there in the old concept of sublimity to hold us in awe today? · We were told it was an "elevated beauty" but *elevation* then was abstract, cloud stratas were unexplored and were beautiful billows for the imagination to soar through · Now *elevation* means airplanes, speed and scientific achievement, the sensation of being in a cloud world has become an actuality with its own descriptions, and the sublime is again an abstraction demanding symbols for revelation.

Of the two general rooms of thought, whether sublimity is a *beyondness* signifying man as eternal, or whether it is a *hereness* denoting a reverence or rare understanding of life, this magazine readily enters into the latter · The fact of man boring thus far into eternity seems, in itself, worthy of respect and wonder, while his various personal conclusions on feeling sublime, ranging from the glory of a mountain view or of a leaf turning in the sun to repercussions of intellectual force or supreme love, are concerned with a simple wish that may be the beginning of a greater sublimity: the wish to be apart from the tawdry, the picayune, the brutish.

57

The Tiger's Eye | *on Arts and Letters*

DECEMBER 1948 **6** Ruth Stephan, *Editor*
John Stephan, *Art Editor*
John Nerber, *Assistant Editor*

TALE OF THE CONTENTS

58

41

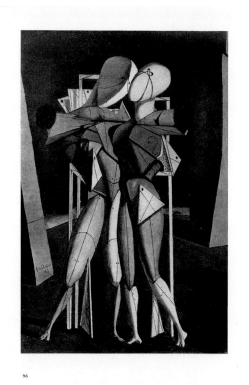

96

97

100

101

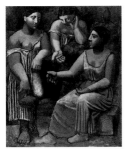

Pablo Picasso, *Three Women
at the Spring*, 1921. Oil on
canvas, 80 ¼ × 68 ½ in.
The Museum of Modern
Art, New York, Gift of
Mr. and Mrs. Allan D. Emil.
(*The Tiger's Eye* 3:93)

of 1944, appears in this section as does Willem de Kooning's proto–Abstract Expressionist representation of Electra's brother, *Orestes* (1947). Different mediums are also juxtaposed to great effect. One two-page spread groups two oil paintings, Mark Rothko's *Sacrificial Moment* (1945, page 78) and Arshile Gorky's *Agony* (1947, page 79), with Stanley William Hayter's engraving *Cronos* (1944, page 79). The engraving brings out the strong linear quality of the two paintings, while the more or less contrasting areas of color in the paintings call attention to the shades of light gray to deep black structured by Hayter's engraved lines.

The absence of text over the section's page after page of images—there is no explanation, or even basic captions—is part of *The Tiger's Eye*'s attempt to live up to the ideal in which "each piece is chosen for its own sake and always should be approached as such." It is this naked presentation of images that Williams refers to when he writes "it's a valuable thing to be forced back on one's self, one's own taste—or lack of it, so to gain actual and immediate sense contacts with the work of art." Texts printed elsewhere in the issue, however, do resonate with the pictures reproduced just pages away. A short essay by Newman, "The Object and the Image," articulated one angle on the "Ivy on the Doric Column" line of inquiry. Taking ancient Greek culture as his point of reference, Newman compared contemporary European and American approaches to art:

> Greece named both form and content; the ideal form—beauty, the ideal content—tragedy.
>
> It is interesting that when the Greek dream prevails in our time, the European artist is nostalgic for the ancient forms, hoping to achieve tragedy by depicting his self-pity over the loss of the elegant column and the beautiful profile. This tortured emotion, however, agonizing over the Greek objects, is always refined. Everything is so highly civilized.
>
> The artist in America is, by comparison, like a barbarian. He does not have the super-fine sensibility toward the object that dominates European feeling. He does not even have the objects.
>
> This is, then, our opportunity, free of the ancient paraphernalia, to come closer to the sources of the tragic emotion. Shall we not, as artists, search out the new objects for its image?[57]

In a seeming paradox, Newman advocates the pursuit of the new as the best means of approaching the eternal and essential. He localizes the potential for new culture in America, because it lacks the constraints of precedent. The freedom from beauty enjoyed by the barbarian renders nostalgia nonsensical, and further renders the barbarian, rather than the civilized, the ideal state from which to pursue human truth, or in Newman's words "to come closer to the sources of tragic emotion." Whereas this text was Newman's verbal response to the issue's theme, his 1947 painting *Death of Euclid* (pages 42, 80), reproduced with the other artworks, was his visual response. Newman had studied at the Art Students League in New York during the 1920s and continued painting, though not exhibiting, through the 1930s. He stopped making art altogether around 1939–40. In light of the devastation of World War II, how and what to paint presented itself as a

Page 45: Pablo Picasso, *Three Dancers*, 1925. Oil on canvas, 84 ¾ × 56 in. Tate Gallery, London
 (*The Tiger's Eye* 3:91)

Page 46: William Blake, *America a Prophecy*, 1793. Printed at Atelier 17, New York, 1947.
 Simultaneous intaglio and relief inking, plate: 3 ⅛ × 2 ⁵⁄₁₆ in.; sheet: 6 ⁷⁄₁₆ × 5 ⅛ in.
 Collection Julian and Carla Hayter (*The Tiger's Eye* 1:72)

Page 47: *Stanley William Hayter, *Falling Figure*, 1947. Engraving, soft-ground etching and scorper
 work with surface-printed colors, plate: 17 ¾ × 14 ⅞ in.; sheet: 26 ⅜ × 20 ⅛ in.
 Yale University Art Gallery, Everett V. Meeks, B.A. 1901, Fund (*The Tiger's Eye* 8:17)

Page 48: Len Lye, *Knife Apple Sheer Brush*, 1949. (*The Tiger's Eye* 7:67–68)

Page 49: Stanley William Hayter, *White Shadow*, 1947. Oil on canvas, 44 ⅞ × 32 ¹⁵⁄₁₆ in.
 Collection Julian and Carla Hayter (*The Tiger's Eye* 7:66)

Page 50: Paul Klee, *Dance You Monster to My Soft Song!*, 1922. Watercolor and oil transfer drawing
 on plaster-primed gauze, bordered with watercolor on the paper mount,
 gauze approx.: 13 ⅞ × 11 ½ in.; gauze and border: 15 ¾ × 11 ½ in.; paper: 17 ¾ × 12 ⅞ in.
 Solomon R. Guggenheim Museum, New York, Gift, Solomon R. Guggenheim, 1938
 (*The Tiger's Eye* 7:71)

Page 51: *Rufino Tamayo, *Girl Attacked by a Strange Bird*, 1947. Oil on canvas, 70 × 50 ⅛ in.
 The Museum of Modern Art, New York, Gift of Mr. and Mrs. Charles Zadok (*The Tiger's Eye* 1:66)

Page 52: *André Masson, *Hesperide*, 1946. Color lithograph, composition: 18 ¹¹⁄₁₆ × 14 ⅞ in.;
 sheet: 25 ⅝ × 19 ¹¹⁄₁₆ in. Collection of Lawrence Saphire

 *Joan Miró, *Two Acrobats in the Garden at Night*, 1948. Lithograph, composition:
 21 ¾ × 16 ⅛ in.; sheet: 25 ⅞ × 19 ⅝ in. The Museum of Modern Art, New York,
 Abby Aldrich Rockefeller Fund (*The Tiger's Eye* 8:22)

Page 53: *Ezio Martinelli, *Bison*, 1949. Etching and aquatint, plate: 12 × 2 ¹⁵⁄₁₆ in.; sheet: 14 ¾ × 6 ⁵⁄₁₆ in.
 The Museum of Modern Art, New York, Purchase (*The Tiger's Eye* 8:38)

Page 54: Ruth Stephan, *A Response*, 1949 (*The Tiger's Eye* 7:32)

Page 55: *John Stephan, *Portrait of Ruth*, 1949. Oil on canvas, 34 × 28 in. Collection of Diana and
 Duncan Johnson (*The Tiger's Eye* 7:35)

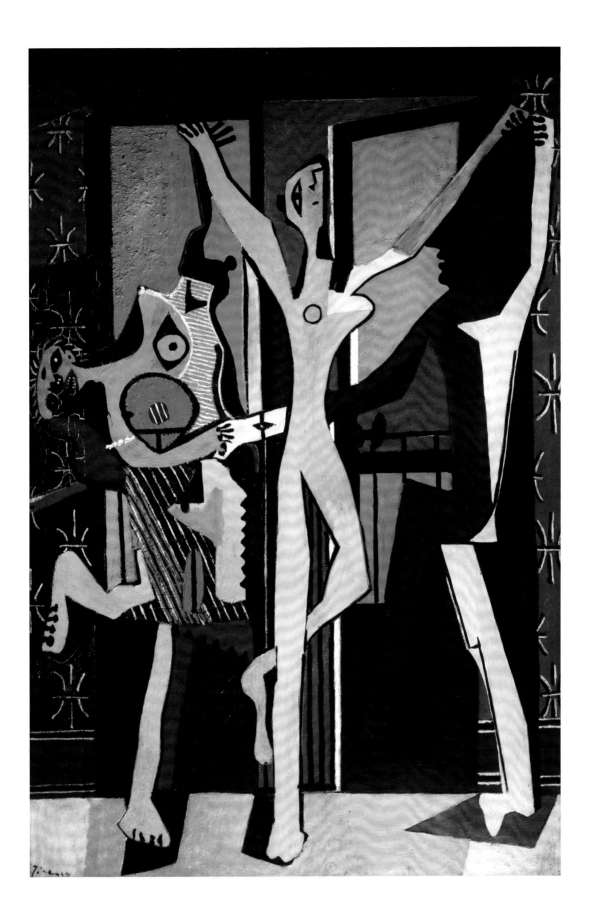

Knife Apple Sheer Brush

Take a	knife
To an	apple
The pith lies	sheer
With the mind take a	brush
Peel the skin of your own	pith
See the sinews of	feeling
Traced in the glow of vegetable	dyes
Pinioned by the black	action
Of the cadmium	sun

HAYTER

Effigies seen in the name of Hayter
Twang echoes into ritual

For YOU of HIM
In gamut of aesthetic

With cat gut to a violin
As boots floor walls to his painting

WHO on this floor of a gallery
Self-lured to savour hypnotic mind juice

Lick the cat chops of experience
Where mind stands confronted with mind

Not by museum label or institution
But by the work of one man

Seeking responsibility for his version
Of the transparent skin of the universe

Revealing unique and priceless scarecrows
Guarding the seeds of experience

Acrid dyed flamboyant and confident they stand
Vital as those of exhumed cultures

They state the primitive faith in eternity
In colors of life and death

Such living candescent signs
We ignite now to show

Some luminous version of the future
From ourselves long ago

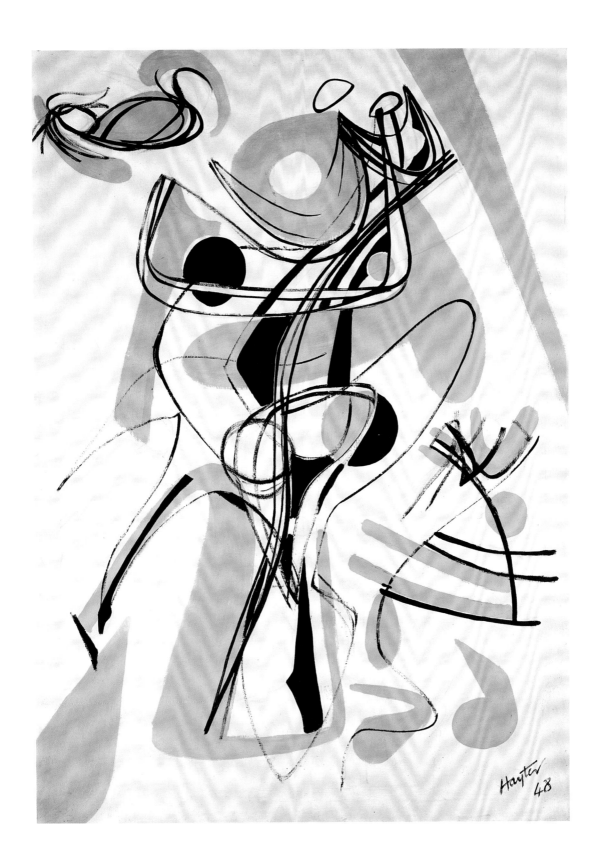

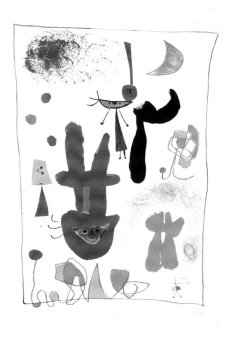

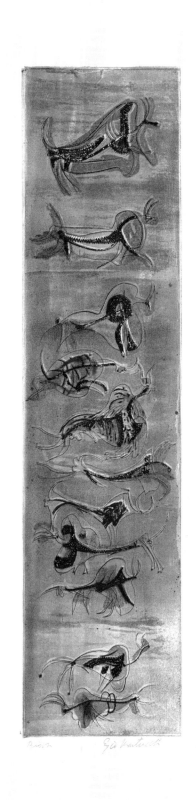

A Response

A sea, a cliff, a temple,
and an eye to see them.

We will not journey today.
This antique arid antic earth
where animals adapt or leave by vanishment
is moving silver to yellow colorific pyramids.

You and you and I are the greyed pageant
yet within we swell, our eyes insist
our vision swell to colossus patient life
for patience here is sand, as sand is changelessness.

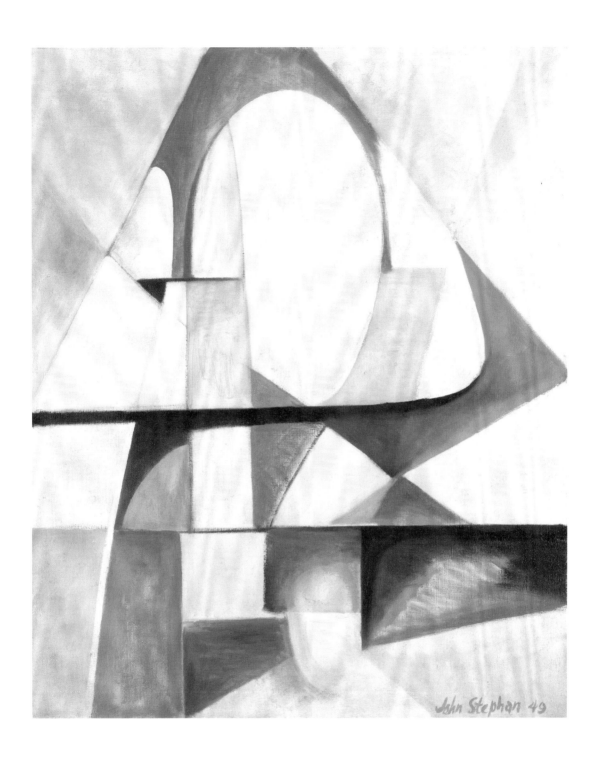

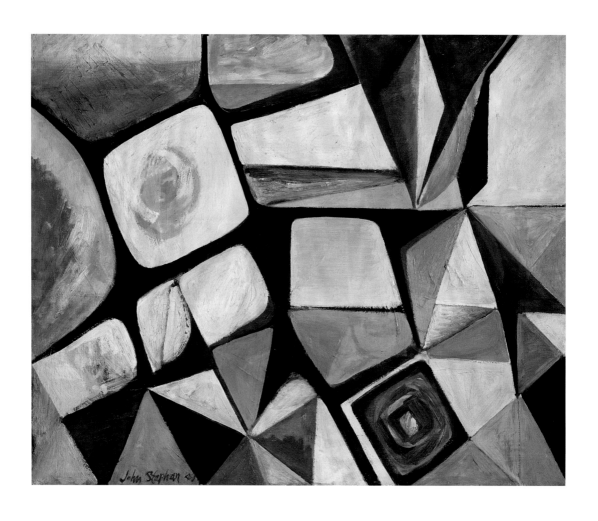

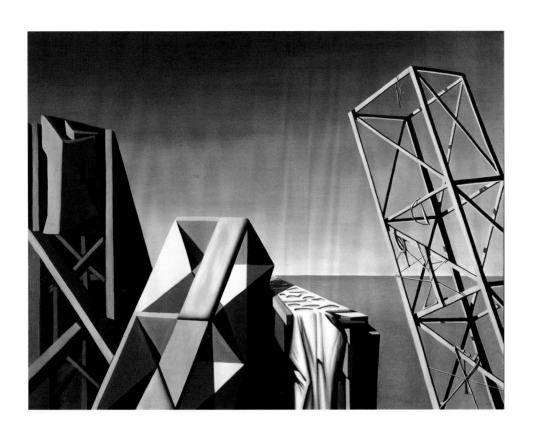

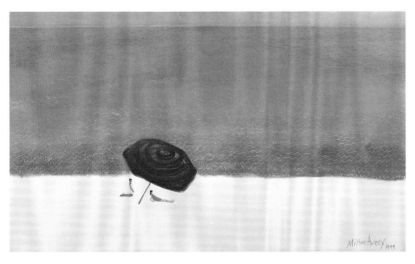

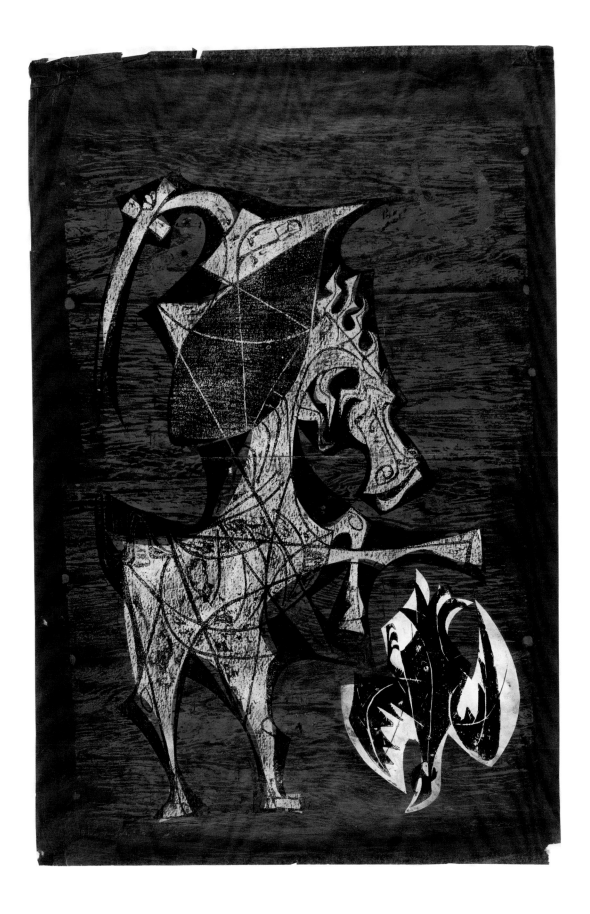

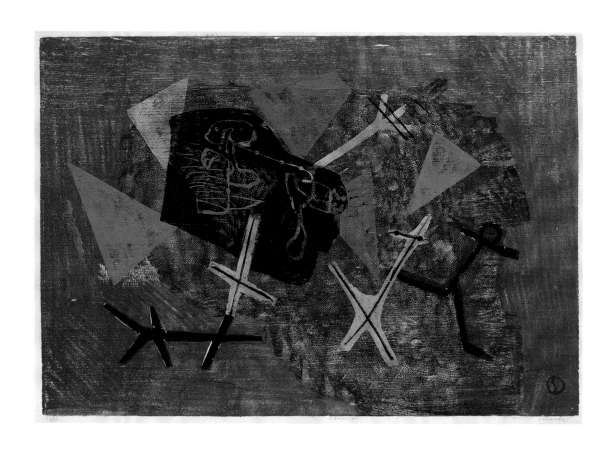

61

moral crisis. As he described it in retrospect, "we actually began, so to speak, from scratch, as if painting were not only dead but had never existed."[58] When Newman began to paint again in 1944, he almost immediately developed the style and concept that became the basis of his mature work, and at the same time he destroyed all of the work he had made previously. In a sense, his concern with the new can be seen as an integral part of his own creative life and artistic development during these particular years, as well as the postwar blur of everything having changed but not quite clear exactly how. Even his painting's title *Death of Euclid* references the new irrelevance of the old order.[59]

John Stephan weighs in on the subject in his short essay "Of Gods and Men":

Pablo Picasso, *Marie-Thérèse Looking at a Sculpted Self Portrait of the Sculptor*, 1933; printed 1939. Etching, 10 ½ × 7 ⅝ in. The Museum of Modern Art, New York, Abby Aldrich Rockefeller Fund (*The Tiger's Eye* 3:17)

> The significance of the image as a revelation of man cannot be ignored. The ancient Greeks, by way of myths, created gods in their own image, magnifying their own qualities with candour and fantasy. By this reflection of themselves, they were reassured in their natures. Being uninhibited and passionately curious, they investigated the phenomena of reality as it concerned man, conceived the tragic nature of man, and established the patterns of democracy, science, drama, art, philosophy, and even the religion, of the Western world.
>
> Today Western civilization has gone far from Greek origins. In creating our image of God, we rejected our natures as being man's, and then claimed that we were created in the image of our God, which we are ever failing to resemble.
>
> This denial of the nature of man has developed man's cunning and his art of hypocrisy. Today we are living in a Babel in which the noise is terrific. Our machines, like eunuchs, guard the gates of the city. We are confronted with a host of giant medicine-men chanting and prescribing rites and magic that always end in our disembowelment as the final act. Man as a romantic creature has been bypassed, and is threatened with becoming, by way of vivisection and mechanical reconstruction, a robot.
>
> There are artists with true perception of the phenomena of reality and, as though inspired by Dionysus, are creating images that reflect the man today. By such revelation man can penetrate the maze and destroy the spectre of the Minotaur.[60]

Stephan, like Newman, builds his argument on a foundation of faith in essential human nature and identifies true art as that which strives for the truth of that nature. But whereas the new for Newman is presented as a specifically American freedom from the overwhelming history of Western civilization, Stephan holds up the more general values of curiosity, passion, and honesty as the means of pursuing truth, as much today as in ancient Greece. A group of paintings by Stephan dating from 1947–49 demonstrate his ongoing dialogue with ancient culture, and broadens the dialogue to non-Western civilization as well. The brief commentary in the Tale of the Contents for a later issue in which *The Pyramid Confronts the Sea* (page 56), *Portrait of Ruth* (page 55), and *Oedipus* (page 105) are reproduced, states that a "trip to Peru in 1946 and his interest in the Inca civilization has effected his recent

painting. John Stephan is one of the lively group of artists who are insisting on new images for art today."[61] Stephan's insistence on new images does not depend on the obliteration of the past, however; even his representation of his wife and coeditor of *The Tiger's Eye* views this very present being through the timeless lens of ancient culture.

Without making any overt reference, the two essays speak to each other. Stephan and Newman consider the same theme from different angles, and the resulting contrast is as provocative as what either of them has to say. The other texts and images that are bound together similarly inflect each other, and the effect of dialogue expands to conversation. No one text, point of view, work or style of art can be the last word as the whole magazine adds up to a different sort of meaning than any, or even the sum, of its parts.

In light of Stephan's essay, William Carlos Williams's letter reads more as a letter to both editors than solely to Ruth Stephan to whom it was addressed. When Williams likens the editorial decision to separate names from works as an "imitation of god," his phrasing resonates with the terms of John Stephan's essay. Williams's letter continues: "the profusion and the excellence of the reproductions is something that I, personally, delight in. You did me a great favor in showing me that etching of Picasso's, *Sculptor and Model*. That's a wonderful piece of work bringing out as it does, so simply, the asexual eye of the creator: the 'cold' eye of the artist—and no eunuch either." The choice and quality of reproductions were John Stephan's responsibility. Moreover, Williams's use of the term "eunuch" references Stephan's description of the mechanized men of modern life as "like eunuchs." Williams doubles back on the literal meaning of eunuch—here figured exactly what Picasso, as artist and man, is not—even as he suggests his agreement with Stephan's view that in art lies the power to move toward truth.

The magazine figures the reader as participant. This issue's theme of modern responses to classical culture implicates the reader from the first page as he or she becomes a modern responder to Sappho's poem. As one reader's response, Williams's letter is an example of the active reading *The Tiger's Eye* wanted to provoke. *The Tiger's Eye* approached reception itself as a creative act. In a worldview where editors are observers working from a theory of creativity in which reception is a major part of production, perhaps this emphasis on the creative role of receiving completes the picture. Promoting their philosophy, they advertised: "*The Tiger's Eye* is on A public—not the Public—It is looking for Readers who wish to be their own Critics—for Readers interested in an Adventure in Art—for Readers curious about the Imaginative Wealth of our own Age—for Readers unafraid of their own or other people's Aesthetic Opinions—for Readers willing to enjoy new stories, new poetry, new paintings, new Ideas."[62] As John Stephan mused in his notes "the challenge is thrown to contributor and reader alike to make good their responsibilities—no supports are offered," or, as the editors frequently reiterated, *The Tiger's Eye*'s public must make itself.[63]

Pablo Picasso, *Sculptor and Model Looking at Herself in a Mirror Propped on a Sculpted Self Portrait*, 1933; printed 1939. Etching, 14 ½ × 11 ¹¹/₁₆ in. The Museum of Modern Art, New York, Abby Aldrich Rockefeller Fund (*The Tiger's Eye* 3:20)

A direct approach is needed in presenting the arts of today which cannot be accomplished through an historic or analytic process, nor through editing a dope sheet or holding a television quiz program. Since its first appearance *The Tiger's Eye* has observed the critic as one who stands with his back to paintings making them serve as a backdrop for his jargon and distracts the reader from what really is there. Now, in addition, harm is being done by those who have positions as trustees of the art of all centuries and who fear so desperately for the glory of the past that they accept only the artists willing to serve as its pallbearers.

No matter how imposing the array of well and not so well wishers, it is apparent that if anything is to come out in writing on art, it will have to come from those who practice the arts and are mutually concerned with the problem of bringing to light the aesthetic realities which exist today. To them alone is the question of presentation a real one and sincerity essential.

The Tiger's Eye is not concerned with the job of adding to an historic or geographic edifice, but it realizes the advantages gained in the past by the impressionist, cubist and surrealist movements, and is looking for the arrival of creative writers who have the courage to speak for the arts of the mid-twentieth century.

—Editorial Statement, *The Tiger's Eye*, Number 7, March 15, 1949, page 57

One contemporary critic commented that *The Tiger's Eye* was "colorful and lively, and precisely what has been needed so badly in the field of the little magazine—a more provocative dish for the soup, whether good or bad."[64] Similarly, a promotional circular for the magazine, itself printed in red ink on light blue paper, promised "a colorful collection," referring not only to the magazine's exciting contents, but also to the different colors of ink and paper used in making the magazine, and to the color reproductions of selected works included in each issue. *The Tiger's Eye*'s emphasis on the creative work of reception made conveying the contents all the more consequential, thus raising the stakes of the magazine's form.

The Tiger's Eye's "direct approach" was best realized in its presentation of work without immediately identifying the artist or author responsible for it. The separation, however, was intended only to eliminate distractions, not to obscure the identity of the contributors. The Tale of the Contents, always located in the center of each issue and printed on a heavier paper stock in a clearly contrasting color, was meant to be found easily by sight or touch.[65] Indeed, John Stephan's design for *The Tiger's Eye* was not concealing on any front, exemplifying the conviction that to those who practice the arts "alone is the question of presentation a real one and sincerity essential." His concept was straightforward: "what is intended & planned but not said" would be "evident by being carried out," and what was intended and expressed would find its place in the editorial statements.[66]

In Hayter's essay for the eighth issue, he noted that "when man discovered that facts did not necessarily have to be considered one by one, when he began to compare individual phenomena and group them by analogy, then to compare the groups with one another, he acquired an instrument of great value."[67] He could be describing *The Tiger's Eye*'s presentation strategy. Objects were reproduced and images were grouped and juxtaposed in a way uniquely possible in the bound form. Though each issue included two or more reproductions in color, the majority of the magazine's reproductions were black and white and always either half or full page in size. Whatever the size of the original objects, here they became images that fit the $10\frac{1}{4}$ by $7\frac{1}{4}$ inch logic of the page. The scale of the reproductions and the elimination of color emphasized the contrasts and comparisons Stephan suggested in his layouts. Inevitably the magazine did suggest meanings, but through its compositional systems rather than written interpretation. And just as the editors insisted on treating criticism as literature, such that critical writing must be true to its own form, so did they hold the magazine to an analogous standard of truth to its own form.[68]

The "facts" and "individual phenomena," to use Hayter's terms, that Stephan "grouped" and "compared" included not only the works of art he chose to reproduce, but also the typefaces, colors of ink, and colors and weights of papers—all of the elements that made up the physical magazine. In determining the look of the written contributions, Stephan turned to the *Book of American Types* published by the American Type Founders. Within each number of *The Tiger's Eye* Stephan used several different typefaces, often differentiating among contributions by switching the print. The differences were subtle enough, even when the color of ink changed, that presentation

never overwhelmed content. Yet, the slight shifts were enough to alert the reader to the process of reading. The varied papers within each issue became another defining feature, calling attention to the magazine as object even as one turned through its pages.

The format of the magazine is intimate, encouraging the reader to hold the volume in both hands as if closing a circuit. Even the magazine's cover, as initial point of contact, encourages engagement. Printed from a painting by John Stephan, the cover depicts a tiger's visage. Open, *The Tiger's Eye* is two hands full of magazine, asking to be held. Closed and frontal, the cat peers out of the roughly face-size format. Eye contact with the receiver initiates the communication that would then continue while looking through the pages inside. Each of the three paintings Stephan made as bases for *The Tiger's Eye* covers is horizontal in composition, organized such that when printed the image wraps the magazine, splitting the horizontal expanse into front and back covers. The first of Stephan's cover paintings pairs two unmatched sides of an abstracted tiger's face on either side of a central vertical axis.[69] Most noticeably asymmetrical are the pair of eyes that do not match each other: the eye on the right side of the painting and the front cover of the magazine is more human-like, and that on the left of the painting and back of the magazine more like the eye of a cat. Despite this disparity, the eyes are actually, and appropriately, the most clearly described features of this tiger. Areas of white, brown, and black paints—primarily triangles and arcs— fit together, only hinting at the rest of the face. Six radiating lines of paint suggest whiskers. Stephan's geometric approach recalls his mosaic work of the preceding decades. The process of making the magazine, in which he gathered the bits—photographs, typefaces, inks, papers—that would fit together into a larger whole, can be seen as similarly mosaic-like in sensibility, and like a mosaic, the overall picture presented by *The Tiger's Eye* ultimately comes together in the eye of the beholder.

John Stephan put together one volume after another in which the form and the content are inextricably linked elements of the aesthetic experience. A less physical, though no less defining, element of the magazine form is seriality. Stephan gave a visual nod to the magazine's quarterly publication by using one cover image for each year of publication, simply altering the colors printed to differentiate among the numbers. Seriality created a temporal structure organizing reception. Mark Rothko—with twelve paintings published —was the most frequently reproduced artist in *The Tiger's Eye*; over the two and a quarter years of its publication, the magazine documented the evolution of Rothko's artistic approach for his contemporaries. Periodical publication was uniquely suited to tracking and publicizing the artist's developments.

When five of Rothko's paintings were reproduced in the first issues, the artist was reluctant to write about the work: "I feel extremely honored that you are considering reproducing some of my oils. But may I beg you that you do not urge me to say anything about my own things. I have really decided that one Must Not do so."[70] Rothko's reluctance is evocative of *The Tiger's Eye*'s own editorial commitment to presenting work on its own terms. The watercolor and oil paintings reproduced in Number 1 appeared with no accompanying text by the artist, but the grouping created its own meaning.

** The Tiger's Eye*, Number 1, October 1947, Front cover

From *Ancestral Imprint* (ca. 1946, page 76) to *Personages* (ca. 1946, page 75, published in *The Tiger's Eye* as *Ritual*) to *The Source* (1945/46, page 77), mysteriously organic forms occupy a composition of horizontal registers. Repetition made the strong compositional device of horizontal stacking much more visible than it would have been with the reproduction of a single painting.

Rothko did write for *The Tiger's Eye*, Number 2, but it was in response to the issue's theme, "The Attitudes of Ten Artists on their Art and Contemporaneousness" rather than comments on specific paintings:

> A picture lives by companionship, expanding and quickening in the eyes of the sensitive observer. It dies by the same token. It is therefore a risky and unfeeling act to send it out into the world. How often it must be permanently impaired by the eyes of the vulgar and the cruelty of the impotent who would extend their affliction universally.[71]

Again, Rothko's comments echoed the philosophy of *The Tiger's Eye*, though here more overtly in terms of reception. Readers of Numbers 1 and 2 would understand that Rothko had taken the risk, using *The Tiger's Eye* as one vehicle for sending his images "out into the world."

Sacrificial Moment, reproduced in Number 3, retains a faint background of the horizontal registers characteristic of the group of Rothko's paintings reproduced in the first issue, but the composition is more dispersed across the canvas. By Number 6, the painting included by Rothko is much less drawn and the composition is defined by the flow of areas of painted color rather than an underlying structural device.

By Number 9, when a second group of five paintings by Rothko is reproduced, the disorderly flow has become more ordered into compositions hinging on clearly interdependent areas of color, dispensing not only with the drawing but also with any clear relation between figure and ground. In this issue, *The Tiger's Eye* summarizes:

> The first exhibit of his paintings that Mark Rothko considered important was in 1945 at Peggy Guggenheim's gallery, Art of This Century. He was born in Dwinsk, Russia, came to the United States in 1903, grew up in Portland, Oregon, and came to New York in 1927. He has an exhibit every year at his present gallery, each time showing his development in his study of shapes and color. For the last two years he has not used titles for his paintings.[72]

The editors verbally trace the artist's recent development even as the reproduced paintings document that development visually. A statement by Rothko written to accompany these images ties together notions of the temporal and the formal as conditions of reception:

> The progression of a painter's work, as it travels in time from point to point, will be toward clarity: toward the elimination of all obstacles between the painter and the idea, and between the idea and the observer. As examples of such obstacles, I give (among others) memory, history or geometry, which are swamps of generalization from which one might pull out parodies of ideas (which are ghosts) but never an idea in itself. To achieve this clarity is, inevitably, to be understood.[73]

Rothko's statement evokes the concerns of making the magazine as much as it illuminates those of his own painting practice.

Certain people always say we should go back to nature.
I notice they never say we should go forward to nature.
It seems to me they are more concerned that we should
go back, than about nature.

If the models we use are the apparitions seen in a dream,
or the recollection of our pre-historic past, is this less part
of nature or realism, than a cow in a field? I think not.

The role of the artist, of course, has always been that
of the image-maker. Different times require different
images. Today when our aspirations have been reduced
to a desperate attempt to escape from evil, and times
are out of joint, our obsessive, subterranean and
pictographic images are the expression of the neurosis
which is our reality. To my mind certain so-called
abstraction is not abstraction at all. On the contrary,
it is the realism of our time.

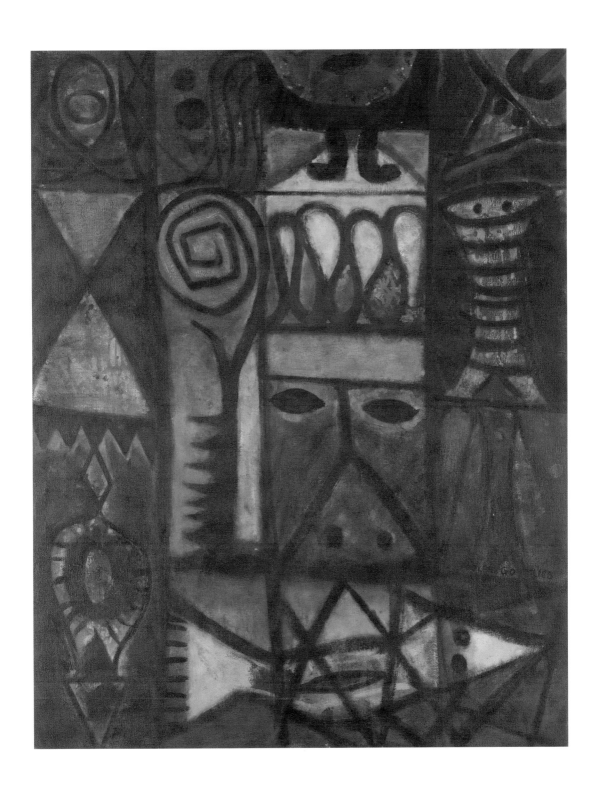

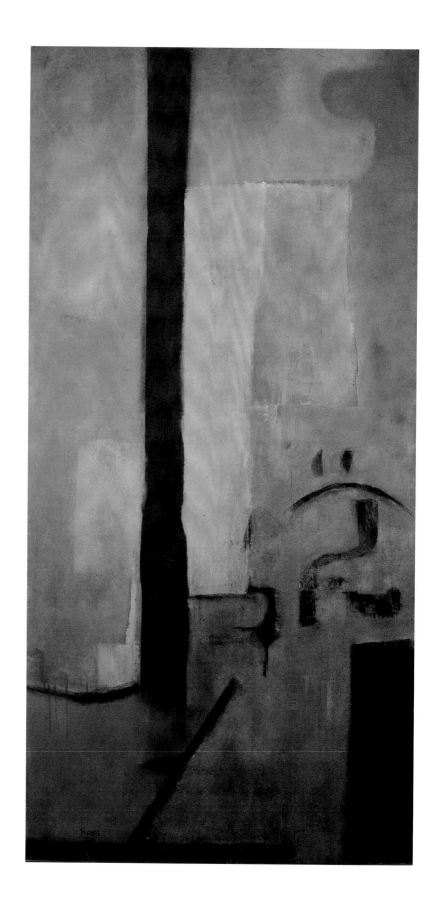

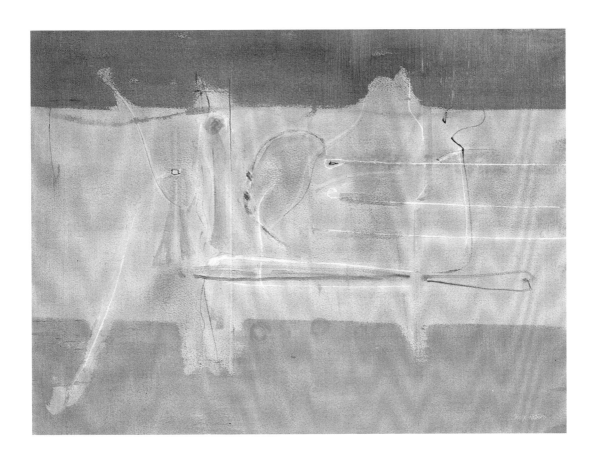

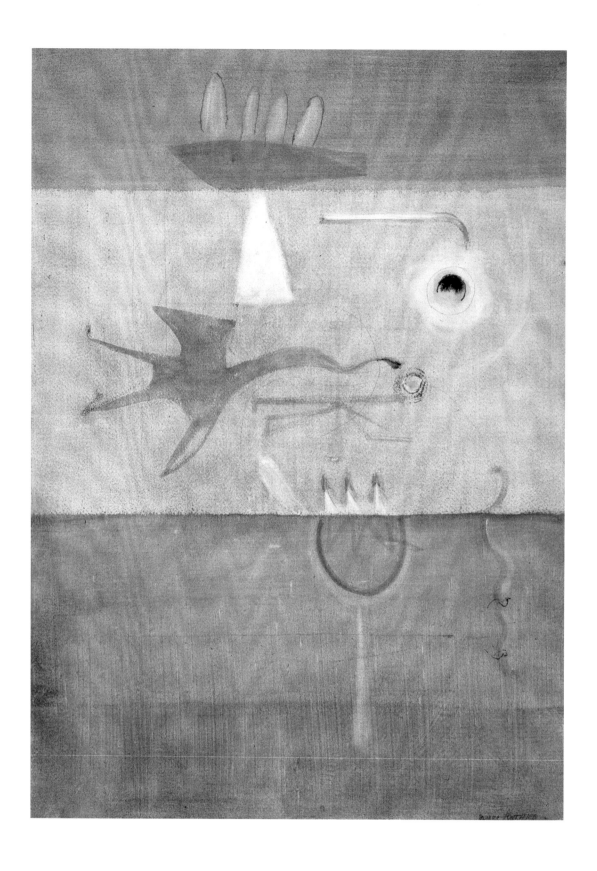

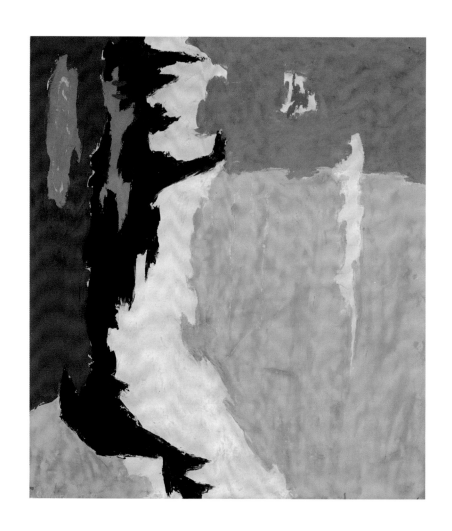

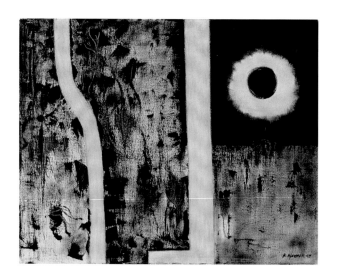

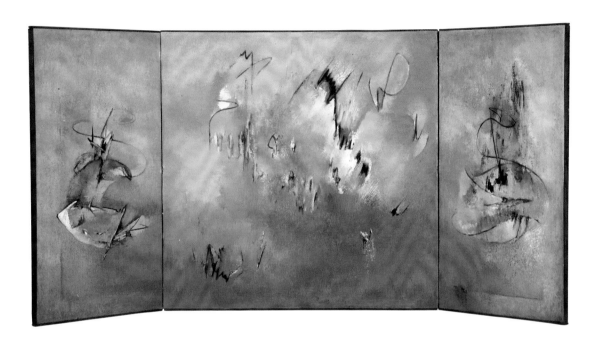

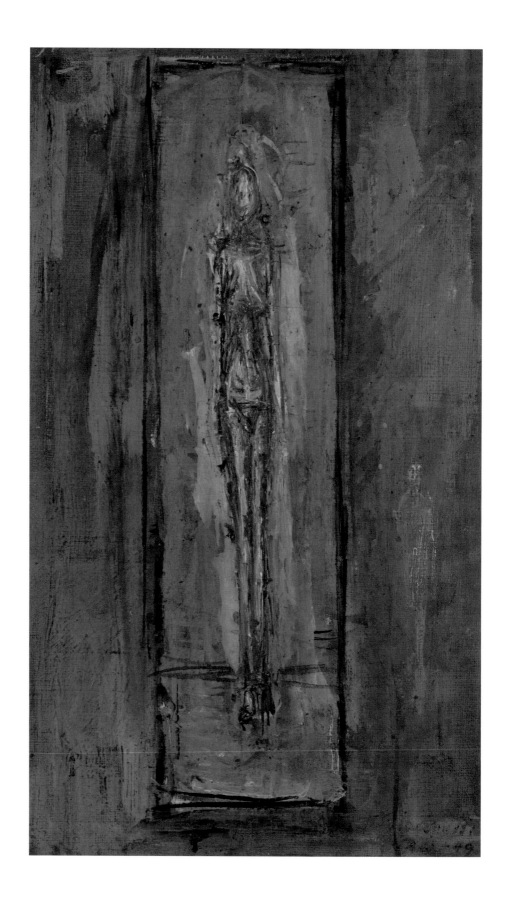

Page 80: *Clyfford Still, *Untitled*, 1945. Oil on canvas, 34 × 31 ¼ in. Private collection

Barnett Newman, *Death of Euclid*, 1947. Oil on canvas, 16 × 20 in. Frederick R. Weisman Art Foundation, Los Angeles (*The Tiger's Eye* 3:101)

Page 81: *Maud Morgan, *Triptych*, 1949. Oil and pastel on canvas and Masonite, 40 ³⁄₁₆ × 80 ¼ in. Addison Gallery of American Art, Phillips Academy, Andover, Mass., Museum purchase

Page 82: *Alberto Giacometti, *Standing Figure in Box*, 1948–49. Oil on canvas, 10 ½ × 6 ¼ in. Yale University Art Gallery, Gift of Molly and Walter Bareiss, B.S. 1940s

Page 83: *Alberto Giacometti, *A Little Bust on a Double Stand*, 1940–41. Plaster, 4 ½ × 2 ⁹⁄₁₆ × 2 ⁵⁄₁₆ in. Yale University Art Gallery, Gift of Anna Hawkes Acoca

Page 84: *Walter Tandy Murch, *Plug*, ca. 1947. Oil on canvas, 9 ¾ × 5 in. Yale University Art Gallery, Gift of Susan Morse Hilles

The Little Magazine in America's aesthetic community is vital only as long as it is a center of creativity and is sponsored by the enthusiasm of writers and artists who flock to it and fill its pages, for it does not adopt and further writers as much as it is adopted and furthered by them. It is, in this age of rapid communication, the counterpart of the English pub, without the ale, and of the Parisian café, without the chairs and coffee, as a gathering place of ideas, of behind the scene discussions and aesthetic friendliness. There is, moreover, no pub or café large enough to hold the talents of this continental country, and American writers are, or should be, tired of the vacuous pity of visiting Europeans who call them lonely. The writer in America is not more lonely but more modest. When the sensitive French writer sits down to write in his room, is he not as alone, with all his cafés and accessible liquid conversation, as the Denver writer in his room. Each faces his mind and his material.

The Tiger's Eye is one of the magazines whose existence would not be possible without the support of creating writers and artists and whose success is dependent on them as well as on the too frequently maligned "public," so much more intelligent than recent intellectual snobs and tight minded critics have wished it to be. Any magazine that tries to succeed otherwise, through pressure groups or proud editorial dictatorship, is in a psychopathic condition. Who can look at our nation of a hundred and forty million people and assume he and a few associates are the only aesthetes in it? It is time to admit the foolishness of such a fatuous assumption and get on with the development of art and literature.

—Editorial Statement, *The Tiger's Eye*, Number 8, June 15, 1949, page 74

The Eastern News Company, the distributor for *The Tiger's Eye*, Numbers 7, 8, and 9, promoted the publications it handled as "natural book store items [. . .] published *periodically* [so] they bring customers into the store regularly." *The Tiger's Eye* in particular, the distributor tells potential dealers, is "a provocative, aesthetic magazine of the contemporary forefront"; appearing quarterly, "each issue is a collector's item."[74]

Ruth Stephan once summarized the purpose of *The Tiger's Eye* as "to widen aesthetic horizons."[75] While such horizon-widening was partly a matter of provocatively presenting a rich range of contents, it was equally a matter of reaching a wide public, and the magazine form—multiple, inexpensive—was made to circulate. In the beginning, *The Tiger's Eye* projected that "while our early distribution will probably concentrate in the New York area, we will have international circulation, and already have excellent contacts in England, on the Continent, and throughout Latin America."[76] The print run for the first issue was three thousand. For the eight issues that followed, between four and five thousand copies were printed.

Complimentary copies of *The Tiger's Eye* always went to each of the contributors. A courtesy to those whose work was published, this inner circle also provided an especially interested audience, and often gave rise to new contributions. Max Ernst, whose paintings were periodically reproduced over the magazine's run, and Dorothea Tanning were pleased to receive the magazine: "we are always so grateful for your thoughtfulness in sending *The Tiger's Eye* and we think it is a very fine magazine indeed. You are certainly to be congratulated on publishing the only worthwhile magazine of arts here in America."[77] Tanning went on to say that she was glad to learn that the editors liked her new oil painting *Palaestra* (1949, page 115). This painting was reproduced in *The Tiger's Eye*, Number 7, just two months after Tanning painted it in January 1949.[78] Part of a special section of poets on art, *Palaestra* appeared with a poem dedicated to Tanning by Charles Henri Ford entitled "The Children Going"(1949).

Exchanging copies for those of other little magazines was another way *The Tiger's Eye* found interested readers and contributors. A common practice among little magazines, such exchanges were also an efficient means of keeping track of various avant-garde fronts. Moreover, these copies reached readers with a vested, vocational interest far and wide. Already engaged with art and literature, these readers were all the more interested because of their involvement with running a magazine.[79]

Maud Morgan, *Sheep May Safely Graze*, 1948. Oil on canvas. Location unknown (*The Tiger's Eye* 6:30)

While the creative communities of *The Tiger's Eye* and other little magazines worldwide provided a core readership, the editors wanted to reach a wider audience. In September 1947, the month before the first issue appeared, thirty thousand subscription circulars were printed and sent to bookstores and galleries likely to have their own networks of potential readers. Two thousand copies went to Gotham Book Mart and one thousand to Betty Parsons Gallery; other outlets received similar quantities. Betty Parsons sold subscriptions to people from the visual arts world, and she sometimes ordered subscriptions at her own expense for clients, such as Mrs. Gerrish Milliken, to whom she had sold Maud Morgan's *Sheep May Softly Graze* (1948),[80] which was reproduced in *The Tiger's Eye*, Number 6. A memo from Barnett

Newman to *The Tiger's Eye* shows both Betty Parsons's involvement with the magazine and Newman's involvement with Betty Parsons Gallery:

> I talked with Betty this afternoon and she has sold all her copies. She wants more of them. One copy was sold to [the] Curator of the Whitney Museum who was very enthusiastic. He said that he will recommend it to the Whitney Library and thinks they should subscribe. Betty wants at least two dozen more copies. Saturday is a busy day & Monday is Hedda Sterne's opening, at which time there will be dozens of prospective buyers. Betty has called me to ask you that should you plan to come in to town Saturday that you bring the copies with you. Business is booming.[81]

Though not in conjunction with the exhibition Newman mentions here, Hedda Sterne's 1949 painting *Moon in the City* was reproduced in *The Tiger's Eye*, Number 9.

Response to the promotional material was enthusiastic. Alfred Barr, Director of the Museum of Modern Art, New York, wrote "I am delighted to have the announcement of *The Tiger's Eye* at last. I am sending it along immediately to our Library asking them to subscribe. I look forward to seeing the first copy with real interest. Good luck to you and to it!"[82] Poet Wallace Stevens ordered a subscription in September 1947 in care of the Hartford Accident and Insurance Company. Though subscription orders came in gradually at first, there were over five hundred subscribers to the first issue and over two hundred more for the second. Once issues of *The Tiger's Eye* were out, interest grew and orders began arriving in greater numbers. By late 1948, a typical week brought twenty orders. By this time, subscription numbers were also bolstered by renewals, attesting to the attention-holding capacity of *The Tiger's Eye*. The Cuban artist Mario Carreño, whose paintings were reproduced in Number 2, sent a combination change of address and subscription renewal when he and his wife relocated from New York to Santiago, Chile, in late 1948.[83] The art collector Katherine Ordway, upon receiving a notice that her subscription had expired, sent back the same notice with a handwritten note "please renew subscription."[84] Total subscribers over the magazine's run numbered between fifteen hundred and two thousand, although subscription rates were never this high at any one time.

Over the run of the magazine there were subscribers from all over the world, but by far the most were from the United States. A cursory survey suggests the geographical range of subscribers: approximately fifteen percent of subscriptions came from New York City; other major U.S. cities including Chicago, Los Angeles, and San Francisco recur with some regularity, but none frequently enough to count as a particular concentration. Subscription distribution covered every area of the U.S., sending *The Tiger's Eye* to urban centers, suburbs, and rural areas alike. International subscriptions were relatively few, numbering perhaps one hundred, but equally broad ranging, coming from Europe, Asia, South and Central America, and Africa. Nonetheless, it seems likely that the majority of foreign readers came to *The Tiger's Eye* by means other than subscribing.

The editors did cultivate an international audience and their commitment to bring American culture to foreign audiences was as strong as their

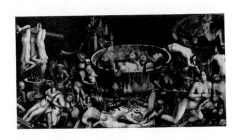

48

49

40

41

Page featuring advertisements placed by Addison Gallery of American Art, John Cage, Willard Gallery, and The Quadrangle Press (*The Tiger's Eye* 6:133)

commitment to make foreign art and literature accessible to their American audience. *The Tiger's Eye* kept track of potential resources for international distribution. A newspaper clipping saved in 1948 indicates their interest:

A quasi-government agency designed to interpret American thought and culture to the world and to stimulate public interest in cultural subjects in this country is proposed in a plan announced by Carleton Smith, director of the National Arts Foundation.

The cultural body would tap America's finest artistic resources for foreign peoples and, in this country, would advance creative ideas through the schools and other educational media. It would work in cooperation with the State Department.

Mr. Smith said the plan had been requested by Defense Secretary James Forrestal for presentation to the Hoover Commission for Government Reorganization, of which Mr. Forrestal is a member. The commission could then present it to Congress as a possible forerunner toward the establishment of a quasi-governmental department of arts. Mr. Smith, who recently toured Europe, said the cultural body could supplement the work of the Marshall Plan. At present, he pointed out, America is winning the economic and military conflict, but losing the war of ideas. While this country feeds the Europeans, he said, the Russians are attempting to poison their minds against America.[85]

The Tiger's Eye, while assuredly not aiming to propagate a war of ideas, would likely have been interested in taking advantage of such a government program that might facilitate circulation abroad. Ruth Stephan in particular strategized along these lines, coming up, for example, with the idea that the State Department should subscribe to *The Tiger's Eye* for the American Embassies and consulates abroad, since, as she writes, "not even contemporary books cover the art and aesthetics we do, and I should think it would be a good piece of cultural information for the cultural attaché to have around."[86] Friends and contributor-readers often reported magazine sightings from less official settings around the world. One poet submitting his work reports that he has "been pleased to find four dog-eared copies of *The Tiger's Eye* (three of them the issue October 20th 1948) in Mexico and Central America in the last five months . . . and NOT in libraries! You may be interested in the names of two hotels in which *Tiger's Eye* was racked with the Latin-American *Time*, etc."[87] Howard Mitcham, in his tombstone-rubbing essay "The Angels of New England," published in Number 9, ranks "tombstone carving from old New England towns, in their modest way, with the great relief carvings of Assyria, Byzantium, China, or any place else where men have felt the universality of stone, have felt empathy with it, and taking chisel in hand have realized the vitalizing force and form buried within" and asserts that the faces carved by this unknown sculptor are "secure in the stream of universal art without epoch."[88] Mitcham reports that *"Tiger's Eye* gets around; many people have told me about seeing the angel's faces, people from North Carolina, Mississippi, and Paris."[89]

Subscribers were not the only readers, of course, and copies of *The Tiger's Eye* were also available at bookstores and newsstands. One reader wrote that though she was not a subscriber, she had not missed an issue, simply

Howard Mitcham, Tombstone rubbing from the series *The Angels of New England,* 1949. *(The Tiger's Eye* 9:41)

preferring to purchase *The Tiger's Eye* on the stands, "rather than subscribe because the beautiful covers which Mr. Stephan designs are often ruined in the mails."[90] Indeed, the approximately fifteen percent of subscribers from New York does not accurately reflect readership, since New York had an especially high concentration of bookstore distribution. After the drop in New York sales with the second issue, published December 1947, J. M. Blanke's services were no longer used and *The Tiger's Eye* handled distribution itself, until Eastern News Company took over with Number 7, in March 1949.

When the editors took over distribution with Number 3, published March 1, 1948, they took the occasion to make an all out promotional blitz. An additional eight hundred thirty-eight copies were printed over the initial order for four thousand. After taking care of existing subscriptions and retail orders, May and June at *The Tiger's Eye* offices were devoted to a systematic sending out of complimentary copies. Review copies were sent to press outlets. Art magazines including *Art News* and *Magazine of Art* received copies, as did a wide range of newspapers, including not only the *New York Times*, the *Washington Post*, and the *San Francisco Chronicle*, but also the *Tulsa Daily World* and the *Worcester Telegram*. Complimentary copies were also sent directly to a range of prominent literary agents, writers, publishers, and distributors, including the American Trade Press Clipping Bureau, UNESCO, Herbert Read, and Clement Greenberg.

Institutions were of particular interest because every copy that went into a public collection was potentially available to many more readers. The promotional campaign included sending over one hundred museums complimentary copies. These ranged from major New York City museums to university museums to regional institutions.[91] Requests also came from libraries, including institutions as wide ranging as the Cleveland Public Library, the National Farm School and Junior College, the library of the National Gallery of Art, and Middlebury College library to name just a few. A particularly urgent request came from the California School of Fine Arts in November 1948.[92] At this time, Clyfford Still, whose work had been reproduced in Number 3 (page 37), was an important faculty member, and Mark Rothko, who already had six paintings reproduced in *The Tiger's Eye*, had also recently taught there. The editors also established a "college subscription fund," which simply involved sending free subscriptions in order to make *The Tiger's Eye* available at colleges where it would not be otherwise. A cover letter asked that the donated copies be placed where students might read them, and, in a final push, said "it might interest you that many of the colleges that have sent in their own subscriptions are using *The Tiger's Eye* in English and Art classes for discussion."[93] Perhaps most impressive, however, was the extensive and systematic distribution of sample copies to bookstores in every state in the nation.[94]

The Tiger's Eye approached their campaign pragmatically. A descriptive and unabashedly promotional letter accompanied the complimentary copies:

> You have in your hands *The Tiger's Eye*—A new quarterly whose emphasis is on the creative—It offers the significant work of known and unknown artists and writers—It presents reproductions—some in color—and the writings of the artists themselves—not merely their

critics—Among those contributing: Arp—Baziotes—Calder—Carreño
—Gottlieb—Hare—Lippold—Murch—Newman—Noguchi—
Rothko—Smith—Stamos—Stephan—Tobey—Tamayo—Zadkine—
and others—Its writers are of equal significance—But look at *The
Tiger's Eye*—it represents no clique—Its aesthetic is positive—You will
see at once what it would take us pages to describe—We feel that
you will want it in your library for your young and lively artists—So—
there is a subscription blank enclosed at the last page.[95]

It is perhaps ironic that the magazine, which refuses to identify the contributor
in the vicinity of his or her contribution, here clearly relies on the name
recognition of artists to promote the magazine. Similarly, it is worth noting
that the magazine itself did not go without an easily recognized name.
Moreover, although the words "The Tiger's Eye" did not appear on the cover
of the first or second numbers of the magazine, subsequent numbers were
titled. With the second painting made for *The Tiger's Eye* covers, used for
Numbers 5 through 8, John Stephan even painted the title into the compo-
sition (page 105). The difference, of course, is that the magazine presented
itself as a vehicle rather than as art. Indeed, as a vehicle at the service of art, the
magazine's name recognition was critical to getting and keeping contributors
and readers.

In seeking to broaden its audience, *The Tiger's Eye* did not abandon its
core readership. The promotional campaign of late spring 1948 was also
the occasion of a "Party for Poets, Painters, and Opinionists," hosted by the
Gotham Book Mart. The invitation printed on light-blue paper was simply
decorated on the front with the numeral three printed in gold and reddish
brown ink. The typeface and color of the number were those of the cover
of *The Tiger's Eye*, Number 3, and meant to be recognizable to the party's
culturally informed invitees. William Carlos Williams, who did not actually
make it to the party, wrote his apologies, commenting insightfully on
the complex function of such events: "I hope it went over well—that is that
the usual bunch of grafters and publicity seekers showed up. But there is
always a residue of the timid young [. . .] who really *need* such parties."[96]

The Stephans continued to distribute the magazine themselves with
their small office staff for the next three issues, turning down an initial
proposal from Eastern News, stating "We have found that it really pays us to
handle our own distribution, particularly since we can then know exactly how
we stand at any given moment."[97] But handling distribution themselves
was an immense amount of work, and even with all this work, the numbers
were not at the levels they probably wanted. In December, 1948, *The Tiger's
Eye* calculated its circulation to be just over two thousand seven hundred,
far below the print run of four to five thousand.[98] In early 1949, the editors
reconsidered their commitment to doing it all themselves, and in March,
they circulated a letter to bookstores explaining that starting with Number 7,
Eastern News Company would handle distribution, but assuring clients
that "although we are expanding, we continue our purpose of presenting
a noncommercial quarterly of the beautiful and the provocative in arts and
letters today."[99]

* *The Tiger's Eye*, Number 5,
October 20, 1948, Front
cover

Night is a paradox. Instead of being absolute like a void, its darkness is relative; thus all ships on the ocean at night cover their lights in order better to see. It is a realm filled with infinite things seen and envisioned, wherein, as if from nowhere, realities make their first appearances; where all man's perceptions converge at a horizon; where man loses and finds hope; where he sleeps in forgetfulness and dreams in terror; where anything might happen and so be ascribed to magic.

It becomes a room filled with black mirrors capable of great revelation, as much of man's nocturnal vision is illuminated from within himself, the image and light being one, so that with courage he may emerge as he chooses, freed from confusion and despair.

It is the splendour of the moonlight and stars and the bitter thought of the bottomless pit.

Night is a shell wherein man dwells in oblivion.

Night is an enigma whose seductiveness man must both resist and succumb.

—John Stephan, "Night," *The Tiger's Eye*, Number 9, October 15, 1949, page 68

The Tale's End

"You can't do that to us! There just is not anything like *The Tiger's Eye* on the market. We sat here by the fire the other night, when my sister and her husband were down, and talked about how literature is made and what a magazine like *The Tiger's Eye* can do to push back horizons."[100] When *The Tiger's Eye*, Number 10, and subsequent issues did not come out as scheduled, the absence did not go unnoticed. Ruth Stephan's response explained: "John and I just couldn't do all the work, so we had to suspend—now we hope to come out, irregularly at least, and are planning a new issue for late fall. At last we can get on with our own work, which we couldn't do very well with the fast growing Tiger, whose principle food was our time, and was always hungry."[101]

At first, the editors had no intention of ceasing publication altogether. Hibernation became Ruth Stephan's preferred term for describing the magazine's situation, and the poetic tone of correspondence from some readers suggests they were as attached to the magazine as its editors. Upon receiving condolences, "Elisabeth and Eddi Humbro beg to express their deep sympathy and profound sorrow at the untimely demise of *The Tiger's Eye* which during its short and glorious life gave so much pleasure. They send the parents their best wishes and kindest regards," Ruth replied, "John and I deeply appreciate your profound sympathy for the Tiger lately laid in a coffin, and now must tell you that the silly creature is blinking so we feel that it may only be a sleeping sickness. It is mumbling something about making an appearance next fall if it has the proper doctor."[102]

Publishing *The Tiger's Eye* the way they had been up to that point—quarterly and with minimal help—was too much work. Throughout 1950, the editors' plan was to bring out Number 10 late that fall, and specifically after John Stephan's exhibition at Betty Parsons Gallery.[103] Producing the magazine did not leave time for John Stephan to paint and Ruth Stephan to write. Envisioning a different arrangement, Ruth wrote, "we expect to start again in the fall with the business taken care of by a business firm instead of by us, so that we will have more time for the creative part of the magazine and more time for our own arts too."[104]

Notices that *The Tiger's Eye* would resume publication appeared in other little magazines, including *Imagi* and *The Writer*.[105] As late as mid-October, the plan was still to publish Number 10 in November.[106] Then, once it became clear that November would not be possible, they postponed the publication date to early 1951.[107] In the meanwhile, preparations never came to a complete halt. The tenth issue, to be devoted to the theme of language, was to have included notes on the notebooks of Marianne Moore and a selection of Marcel Duchamp's postcards. Comments by Josef Albers, accepted and paid for, were perhaps intended for Number 10 or another issue to follow shortly.[108] As of 1949, the editors were planning a photography issue, which would likely have followed shortly on the language issue.[109] It is regrettable that the language issue was never published: the very discussion format of the opinions, in which several people read the same book or engaged the same question, and then wrote in response to what they received, is paradigmatic of *The Tiger's Eye*'s notion of creativity. The discussion is also, of course, itself an instance of language at work, so it would have

been especially interesting to see the opinions circle back in reference to their very form.

Just as they never stopped thinking about content, neither did they forget about distribution. During the summer of 1950, Ruth Stephan arranged to exchange *The Tiger's Eye* for German aesthetic publications, pursuing her project of assimilating foreign culture and disseminating American culture.[110] A few months before another set had been given to the Hadley School for the Blind, Winnetka, Illinois, for use in their Braille poetry program.[111] During the magazine's suspension, however, concern for distribution of the magazine also starts to hint at concern for posterity. Tellingly, in 1950 another gift from the editors was a complete set of nine issues of *The Tiger's Eye* to the Library of Congress.[112]

"About two years ago I received your kind inquiry about the origin and development of *The Tiger's Eye*," wrote Ruth Stephan during the summer of 1950. She was responding, finally, to a 1947 inquiry from Frederick J. Hoffman. Hoffman's inquiry was research for an updated edition of his book *The Little Magazine: A History and Bibliography*, first published in 1946, and reissued well before Stephan responded to his inquiry. Stephan pleaded overextension as explanation for her delayed response: "Knowing little magazine history as well as you do, you will not be surprised to hear that I was so overwhelmed with work, my husband and I handling the business and production as well as the editorial end, that I had no time to answer you until now."[113] It is true enough that producing *The Tiger's Eye* left no spare time, but it seems that the late response was equally due to lack of motivation. In the midst of making the magazine with no end in sight, getting into the history books was not a major concern. The hibernation phase provided time for not only assessing the current situation, but also reflection over the life of the tiger and a new concern for its memory. Around this time, Norman Holmes Pearson asked the editors to consider giving *The Tiger's Eye* papers to the Yale University Library, explaining that the library was actively collecting the archives of various little magazines.[114] They took this opportunity to ensure the potential for *The Tiger's Eye* to find a place in future histories.[115]

By the spring of 1951, a year and a half after Number 9 was published, it was finally clear that *The Tiger's Eye* would not resume publication. The staff undertook to close out all accounts, refunding paid subscriptions and attempting to collect on accounts that remained outstanding. A preliminary draft of a collection letter documents experiments with many different ways of saying "please pay." Hundreds of copies of *The Tiger's Eye* remained in inventory, though far fewer copies remained of Numbers 1 and 9.[116] In May and early June, *The Tiger's Eye* embarked on one last distribution campaign. On May 21, the editors offered sets of Numbers 2 through 8 to the Library Branch of the Department of State, for complimentary distribution around the world.[117] They also undertook their own massive effort at foreign library distribution. In the last week of May, over one hundred educational institutions around the world received notice that a set of magazines was *en route*. The letter explained that *The Tiger's Eye* "has been read with considerable interest abroad because of the little that has reached there of contemporary art in the United States."[118] Since many American institutions

had subscribed all along or were beneficiaries of the College Subscription Fund, the editors could assume that *The Tiger's Eye* was widely represented in the U.S. They did, however, send sets of Numbers 2 through 9 to forty historically black colleges and universities throughout the country.[119]

After these sets of *The Tiger's Eye* were distributed among institutions where many people could access them — and to institutions specifically and strategically chosen so that the people gaining access were those who might be least likely to otherwise — there still were some copies left, which the editors were eager to transfer to distributors or dealers so that they could continue to be available for interested readers. On June 5, 1951, *The Tiger's Eye* offered "to sell large quantities of our back issues at 40 cents a copy. We have a supply of one hundred copies each of Number 2 through Number 8. Please let us know immediately if you wish to order, as the office will be closed June 11th," which was, of course, just six days later.[120]

Appropriately, if unintentionally, Number 9, the last published issue of *The Tiger's Eye*, was devoted to the theme of night. Titled "A Selection on Night—A Darkness of the Mind or of Nature," this issue included reproductions of work representing a typically wide range of styles, mediums, and historical periods. One of the most poignant images in this context is Ivan Albright's *That Which I Should Have Done I Did Not Do* (1931–41). Albright's painting, familiarly titled *The Door*, was quite well known yet still a source of mystery when published here. It had been shown to great notice as a work in progress at the 1938 Carnegie International Exhibition in Pittsburgh, and in the 1942 exhibition *Artists for Victory* at the Metropolitan Museum of Art, New York, where it was selected best picture. Attention to the picture was not all positive: Clement Greenberg's review of *Artists for Victory* for *The Nation* describes Albright's painting as "a carefully manipulated piece of tripe, [. . .] showing a wormy lavender-dark door with a wreath in its center and a woman's hand on the jamb, everything iridescent with decay, everything confected and concocted, everything the painter had in the way of time, diligence, and bad taste thrown in."[121] Dating from 1931–41, Albright worked on the painting for a full decade. The vertical format of the over eight-foot-tall canvas is nearly too narrow to contain the door represented there. Robert Cozzolino recently commented, "Every inch of its surface painted like a precious miniature," noting how Albright "set the door at a slight angle, creating a long shadow at the right to suggest a shallow space at the left. The hand seems to move toward the doorknob; and we, the viewers, can imagine stepping onto the threshold," calling the work a "powerful meditation on life not lived."[122] Given its notoriety, it is likely that this extraordinary painting was familiar to many looking through *The Tiger's Eye*, yet given its powerful theme and intense detail that could never be taken in at once — or produced at once, Albright apparently could often only complete a quarter of a square inch a day — *The Door* beautifully exemplifies *The Tiger's Eye*'s conviction that there is value in creative and lively viewing and that "newness is not pursued for its own sake, but that there is still something to be found."[123]

The Tiger's Eye began with a statement of its commitment to depend "on ingenuous and ingenious artists and writers, whoever and wherever they are, as they move through the dimensions of curiosity." Putting a theory of

creativity that prioritized reception into practice, this magazine ultimately depended equally on its public. Betty Parsons hoped that artists would live up to their challenge, and William Carlos Williams worried that "damned few" readers would be up to it. The editors kept the faith. Even when no more tiger-faced numbers were to appear, *The Tiger's Eye* continued its attempt to engage ingenuous and ingenious viewers and readers—perhaps a "damned few" but perhaps a few more than Williams expected, and often but certainly not always the same people as the artists and writers—whoever and wherever they might be. They closed the door on new issues, but left open the possibility for *The Tiger's Eye*'s public to continue making itself.

Facing page:

Rufino Tamayo,
Full Moon, 1945.
Oil on canvas, 26 × 36 in.
Location unknown
(*The Tiger's Eye* 1:64)

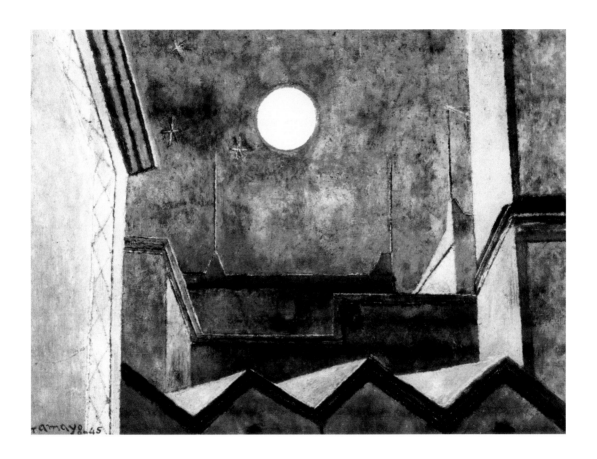

Page 101: *Ad Reinhardt, *Number 18*, 1948– 49. Oil on canvas, 40 × 60 in. Collection of Whitney Museum of American Art, Purchase

*Paul Delvaux, *Procession*, 1939. Oil on canvas, 43 ½ × 51 in. Yale University Art Gallery, Gift of Mr. and Mrs. Hugh J. Chisholm, Jr., B.A. 1936 (*The Tiger's Eye* 6:18)

Page 102: André Masson, *There Is No Finished World*, 1942. Oil on canvas, 53 × 68 in. Baltimore Museum of Art, Bequest of Saidie A. May (*The Tiger's Eye* 3:99)

Page 103: Yves Tanguy, *My Life, White and Black*, 1944. Oil on canvas, 35 ¾ × 29 ⅞ in. The Metropolitan Museum of Art, Jacques and Natasha Gelman Collection (*The Tiger's Eye* 3:104)

*Kurt Seligmann, *Game of Chance*, 1949. Oil on canvas, 22 × 22 in. Yale University Art Gallery, Gift of Thomas F. Howard

Page 104: Editorial Statement, *The Tiger's Eye*, Number 6, December 15, 1948, page 57

Page 105: *John Stephan, *Oedipus*, 1948. Oil on canvas, 44 × 30 in. Drs. Marika and Thomas Herskovic (*The Tiger's Eye* 7:37)

*John Stephan, Cover painting for *The Tiger's Eye*, Numbers 5–8, ca. 1948. Oil on canvas, 23 × 31 in. Collection of John J. Stephan

Page 106: *Mark Tobey, *New York Tablet*, 1946. Opaque watercolor and red chalk on paper on wood panel, 24 ¾ × 19 in. Munson-Williams-Proctor Arts Institute, Museum of Art, Utica, N.Y. (*The Tiger's Eye* 3:55)

Page 107: *Mark Tobey, *Happy Yellow*, 1945. Tempera on paper mounted on board, 16 × 22 ⅝ in. Addison Gallery of American Art, Phillips Academy, Andover, Mass., Gift of Mr. and Mrs. Dan R. Johnson (*The Tiger's Eye* 3:54)

Page 108: *Mark Rothko, *No. 18*, 1946. Oil on canvas, 61 × 43 ½ in. National Gallery of Art, Washington, D.C., Gift of the Mark Rothko Foundation, Inc. (*The Tiger's Eye* 6:20)

Page 109: *Mark Rothko, *No. 9*, 1948. Oil and mixed media on canvas, 53 × 46 ⅝ in. National Gallery of Art, Washington, D.C., Gift of the Mark Rothko Foundation, Inc. (*The Tiger's Eye* 9:113)

*Mark Rothko, *No. 17* [or] *No. 15*, 1949. Oil on canvas, 51 ⅞ × 29 ⅛ in. National Gallery of Art, Washington, D.C., Gift of the Mark Rothko Foundation, Inc. (*The Tiger's Eye* 9:112)

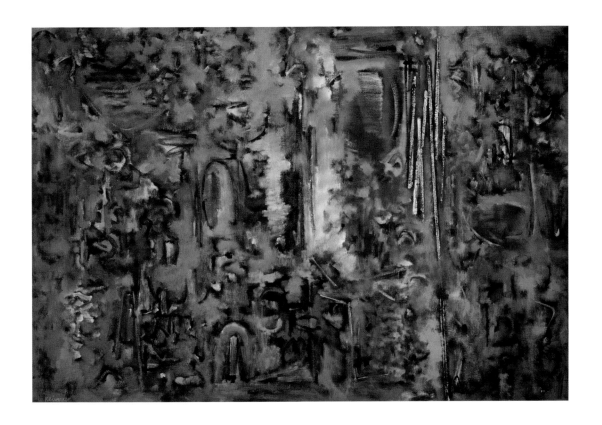

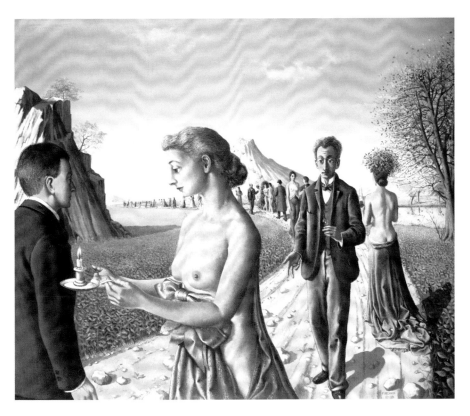

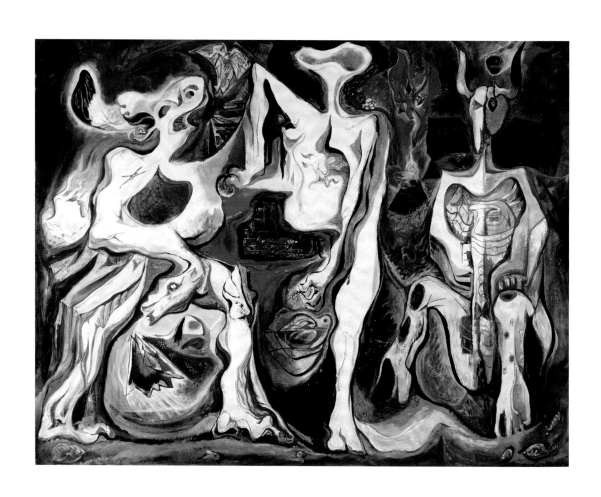

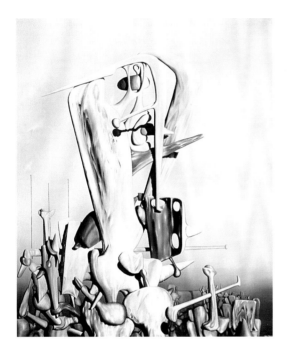

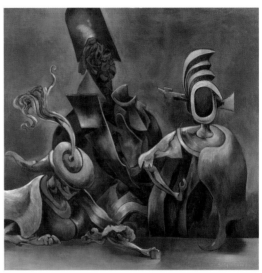

The sublime issue of *The Tiger's Eye* was shaped by the idea that sublimity is the visitor of many and not the exclusive guest of the rhetorical thinker or of religiosity. There is the importance, too, of finding new symbols, for medieval definitions have long been outmoded. What is there in the old concept of sublimity to hold us in awe today? We were told it was an "elevated beauty" but elevation then was abstract, cloud stratas were unexplored and were beautiful billows for the imagination to soar through. Now elevation means airplanes, speed and scientific achievement, the sensation of being in a cloud world has become an actuality with its own descriptions, and the sublime is again an abstraction demanding symbols for revelation.

Of the two general rooms of thought, whether sublimity is a beyondness signifying man as eternal, or whether it is a hereness denoting a reverence or rare understanding of life, this magazine readily enters the latter. The fact of man boring thus far into eternity seems, in itself, worthy of respect and wonder, while his various personal conclusions on feeling sublime, ranging from the glory of a mountain view or of a leaf turning in the sun to repercussions of intellectual force or supreme love, are concerned with a simple wish that may be the beginning of a greater sublimity: the wish to be apart from the tawdry, the picayune, the brutish.

—Editorial Statement, *The Tiger's Eye*, Number 6, December 15, 1948, page 57

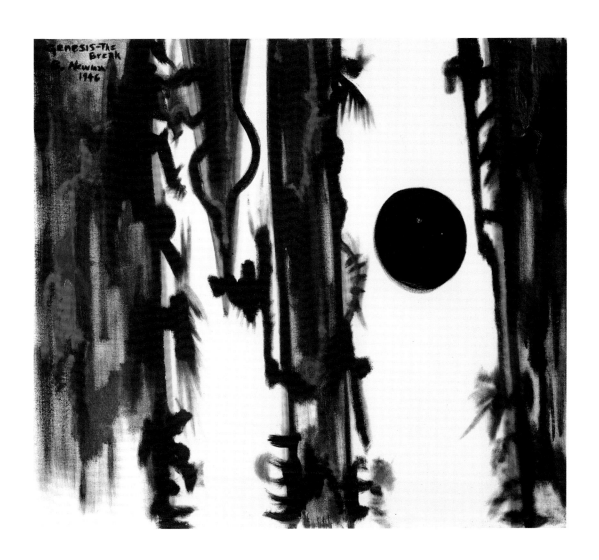

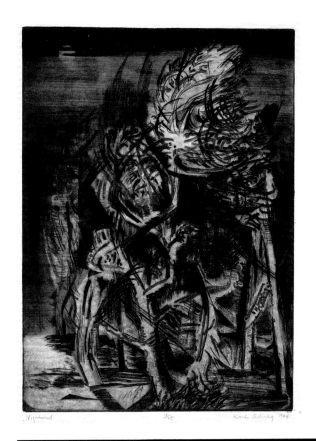

Nightwind ⁵/₂₅ Karl Schrag 1946

On a Street ⁷/₁₈ A Ryan

114

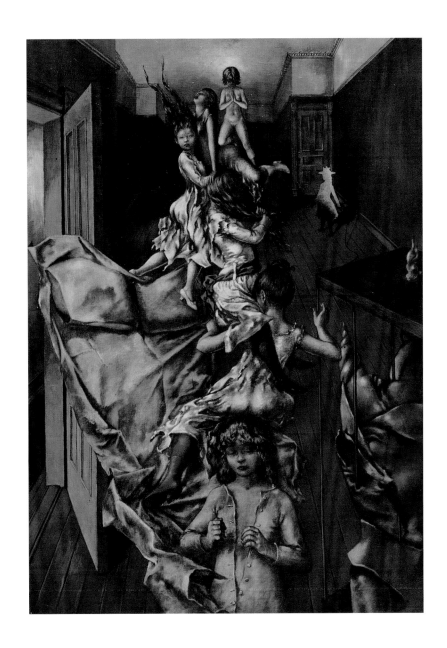

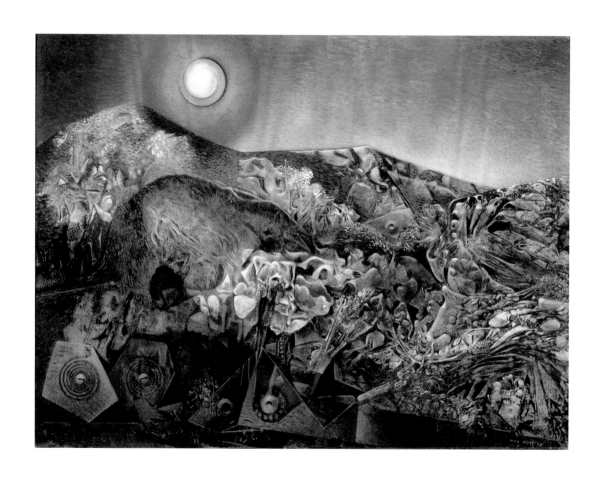

Page 110: *John Stephan, Study for cover of *The Tiger's Eye*, Number 9, ca. 1949. Oil on paper, 17 ⅞ × 23 ¾ in. Collection of John J. Stephan

Rufino Tamayo, *Heavenly Bodies*, 1946. Oil on canvas, 34 × 45 ⅞ in. Peggy Guggenheim Collection, Venice (*The Tiger's Eye* 9:46)

Page 111: Barnett Newman, *Genesis—The Break*, 1946. Oil on canvas, 24 × 27 ⅛ in. Dia Center for the Arts, courtesy of The Menil Collection, Houston (*The Tiger's Eye* 9:59)

Page 112: *Loren MacIver, *Blue Votive Lights*, 1945. Oil on canvas, 34 ⅛ × 38 in. Addison Gallery of American Art, Phillips Academy, Andover, Mass., Gift of Mrs. Bliss Parkinson (*The Tiger's Eye* 6:26)

Loren MacIver, *The Window Shade*, 1948. Oil on canvas, 43 × 29 ⅛ in. The Phillips Collection, Washington D.C. (*The Tiger's Eye* 9:58)

Page 113: *Karl Schrag, *Night Wind*, 1946. Etching, engraving, and aquatint in two colors, plate: 15 × 11 in.; sheet: 20 ¼ × 14 ⅛ in. Yale University Art Gallery, Everett V. Meeks, B.A. 1901, Fund (*The Tiger's Eye* 9:44)

*Anne Ryan, *In a Street*, 1946. Color woodcut, 11 ¼ × 15 ½ in. Courtesy Kraushaar Galleries, New York (*The Tiger's Eye* 9:37)

Page 114: Ivan Albright, *That Which I Should Have Done I Did Not Do*, 1931–41. Oil on canvas, 97 × 36 in. The Art Institute of Chicago, Mary and Leigh Block Charitable Fund (*The Tiger's Eye* 9:57)

Page 115: Dorothea Tanning, *Palaestra*, 1949. Oil on canvas, 24 ½ × 17 ½ in. Private collection (*The Tiger's Eye* 7:86)

Page 116: Max Ernst, *Time and Duration*, 1948. Oil on canvas, 37 ½ × 47 ¾ in. Denver Art Museum Collection: Museum purchase and exchange for the Helen Dill Collection (*The Tiger's Eye* 9:55)

Notes

1. Ann Gibson, *Issues in Abstract Expressionism: The Artist-Run Periodicals* (Ann Arbor and London: U.M.I. Research Press, 1990). See Chapter 2: *"The Tiger's Eye: Not to Make a Paradigm,"* pp. 25–32.

2. The same openness characterized Ruth Stephan's approach as literary editor. Gibson traces Stephan's philosophy as literary editor to her earlier association with *Poetry: A Magazine of Verse* published by Harriet Monroe from Chicago between 1912 and 1943, quoting Monroe's stated editorial policy: "The Open Door will be the policy of this magazine—may the great poet we are looking for never find it shut, against his ample genius: To this end the editors hope to keep free of entangling alliances with any single class or school. They desire to print the best English verse which is being written today, regardless of where, by whom, or under what theory of art it is written." Ibid., p. 28.

3. Ibid., pp. 26–27. The quotation is from an interview Gibson conducted with Grippe on February 20, 1982.

4. Ibid., p. 26. The quotation is from a telephone interview Gibson conducted with Motherwell on April 13, 1982.

5. Stephan discussed this incident in an interview with Robert Brown for the Archives of American Art, conducted in 1986–87, tape 3, side B. Hereafter noted as Brown Interview. Loan forms from the Museum of Modern Art, New York, for *Three Dancers* to go to Melford Photo Engraving Company, *Tiger's Eye* records, ca. 1947–55, Beinecke Rare Books and Manuscript Collection, Yale University Libraries. Unprocessed collection. Hereafter noted as *TTE* mss. It is ironic that when the editors were researching art-reproduction technologies prior to initiating publication, a representative of the publications department at the Museum of Modern Art was particularly generous with detailed advice, suggesting specific engravers and particularly emphasizing the importance of working from the original artwork to ensure high-fidelity color matching. Notes kept by Mary Frances Greene regarding advice offered by Frances Pernas. See *TTE* mss.

6. John Stephan Chronology, unpublished. Archives of the Estate of John Stephan, Newport, R.I. Hereafter noted as Chronology.

7. A notable nineteenth-century prototype for the little magazine in the United States was *The Dial*, Boston, 1840–44, edited by Ralph Waldo Emerson and Margaret Fuller. The twentieth-century history of the little magazine began in 1912 with *Poetry: A Magazine of Verse*. See Frederick J. Hoffman, *The Little Magazine: A History and Bibliography* (Princeton: Princeton University Press, 1946), pp. 2–7.

8. Hoffmann, p. 2. A notable exception to the typically low circulation of little magazines was the revived version of *The Dial*, edited by Marianne Moore during the 1920s, for which the readership has been estimated to have reached thirty thousand. See *The Columbia Encyclopedia*, sixth edition, 2001, entry for "Little Magazine" online. www.bartleby.com/65/.

9. Brown Interview, tape 3, side A. While working at *Poetry: A Magazine of Verse*, Ruth Stephan learned from colleagues that Westport had a high population of writers and artists.

10. Brown Interview, tape 3, side A. John Stephan and John J. Stephan interview, September 1991, transcribed by Margaret Vranesh, unpublished. Archives of the John Stephan Estate, Newport, R.I. Hereafter noted as John J. Stephan Interview.

11. Brown Interview, tape 3, side A. Parsons had studied art with Zadkine in Paris during the 1920s and again in New York during the later 1930s. See Lee Hall, *Betty Parsons: Artist-Dealer-Collector* (New York: Harry N. Abrams, 1991), pp. 37, 67.

12. This exhibition was reviewed by Carlyle Burrows, *New York Herald Tribune*, February 20, 1944.

13. Stephan's mosaic exhibition was reviewed in *Art News*, July 1945, and *New York Times*, June 10, 1945. Stephan's mosaics were installed in the front room of the Mortimer Brandt Gallery in New York; at the same time there was an exhibition of the work of Alfonso Ossorio in the gallery's main room. See Brown Interview, tape 3, side A.

14. Artists whose work was reproduced in *The Tiger's Eye* and who also exhibited at Betty Parsons Gallery, include William Baziotes, Herbert Ferber, Gerome Kamrowski, Seymour Lipton, Boris Margo, Maud Morgan, Robert Motherwell, Walter Murch, Barnett Newman, Jackson Pollock, Richard Pousette-Dart, Ad Reinhardt, Mark Rothko, Day Schnabel, Sonia Sekula, Theodoros Stamos, Hedda Sterne, and Clyfford Still.

15. Brown Interview, tape 3, side A.

16. Chronology.

17. Vèvè Clark, Millicent Hodson, Catrina Neiman, *The Legend of Maya Deren*, vol. 1, part 2, New York: Anthology Film Archives/Film Culture, 1988, pp. 510 11, 516.

18. John J. Stephan, "Ruth Stephan (1910–1974): A Tribute," *The Yale University Library Gazette* (April 1976), p. 227.

19. Calas to Ruth Stephan, March 25, 1947, *TTE* mss. Unless otherwise noted all correspondece is located in *TTE* mss.

20. Chronology.

21. *TTE* mss.

22. *TTE* mss.

23. *The Tiger's Eye* prospectus, n.d., *TTE* mss.

24. *The Tiger's Eye,* Number 1, p. 55.

25. Ruth Stephan to Katherine Kuh, Associate Curator of Paintings and Sculpture, Art Institute of Chicago, November 11, 1947.

26. *The Bridgeport Herald*, summer 1948, clipping in *TTE* files, no date on clipping.

27. "Useful Knowledge," *Gotham Book Mart Currents,* autumn 1948.

28. Henry Miller to Ruth Stephan, March 24, 1950.

29. Ruth Stephan to Mr. Henry Hell, Division of Arts and Letters, UNESCO, December 10, 1948.

30. Gibson, p. 32. It is interesting to note, however, that whereas Barnett Newman was credited by *The Tiger's Eye* as associate art editor of Numbers 2 and 3, and Stanley William Hayter, as well as Kurt Seligmann and Jimmy Ernst were credited as associates on art for Number 9, Hayter's guest editorship of Number 8 is not credited.

31. Joanne Moser, *Atelier 17: A Fiftieth Anniversary Retrospective Exhibition* (Madison: Elvehjem Art Center, University of Wisconsin, 1977).

32. Ibid., p. 2

33. John Stephan to Louis Schanker, March 28, 1949, *TTE* mss.

34. I am grateful to Lawrence Saphire for sharing this information with me. The correction appears in *The Tiger's Eye*, Number 9, p. 72.

35. The impression reproduced here from the collection of the Museum of Modern Art, New York, was recently acquired by that institution. It is the same later state as the print from the New York Public Library reproduced in *The Tiger's Eye*.

36. Correspondence to Inez Boulton, February 8, 1949. Ruth Stephan notes that John Stephan's "new paintings are exceptionally like his ideas." These paintings were included in an exhibition that opened the following week, on February 14, 1949.

37. Barnett Newman to Ruth and John Stephan, n.d., *TTE* mss.

38. Brown Interview.

39. Invoice from Betty Parsons Gallery, May 19, 1947, *TTE* mss.

40. Brown Interview, tape 5, side A.

41. *The Tiger's Eye*, Number 1, p. 55.

42. Barbara Haskell, *Milton Avery* (New York: Whitney Museum of American Art, in association with Harper & Row, 1982), p. 108.

43. *The Tiger's Eye*, Number 1, p. 76.

44. *The Tiger's Eye*, Number 1, p. 39.

45. *The Tiger's Eye*, Number 1, p. 55.

46. Ruth Stephan to Meyer Schapiro, May 7, 1947.

47. *The Tiger's Eye,* Number 4, pp. 77–78.

48. *The Tiger's Eye*, Number 4, p. 42.

49. See Hall, p. 86.

50. Ruthven Todd, undated, unpublished notes, *TTE* mss. Todd also published a longer account: "William Blake Illuminated Printing," *Print* 6,1 (1948), pp. 53–65. *Print* was published by William Edwin Rudge, whose Elmtree Press printed *The Tiger's Eye,* Number 1, the previous year. *Print* borrowed *The Tiger's Eye*'s plates of the same images for reproduction.

51. Carla Esposito, *Hayter e l'Atelier 17*, (Milan: Electa, 1990), pp. 25-26.

52. *The Tiger's Eye*, Number 1, p. 56.

53. *The Tiger's Eye*, Number 1, p. 22.

54. *TTE* mss.

55. Betty Parsons to Ruth Stephan, n.d.

56. William Carlos Williams to Ruth Stephan, April 24, 1948.

57. *The Tiger's Eye,* Number 3, p. 111.

58. Barnett Newman, "Response to the Reverand Thomas F. Matthews" in *Barnett Newman: Selected Writings and Interviews*, ed. John P. O'Neill (New York: A. A. Knopf, 1990). Cited in Jeremy Strick, *The Sublime Is Now: The Early Work of Barnett Newman, Paintings and Drawings 1944–1949* (New York: PaceWildenstein, 1994), p. 7.

59. Strick's catalogue is an excellent consider-ation of Newman's early work and career.

60. *The Tiger's Eye*, Number 3, p. 109.

61. *The Tiger's Eye*, Number 7, p. 58.

62. Prospectus for *The Tiger's Eye*, Number 2, *TTE* mss.

63. *TTE* mss.

64. Cited in *Poetry*, August 1948.

65. Stephan discusses his strategies of making the Tale of the Contents easy to locate in Brown Interview.

66. Undated notes by John Stephan, *TTE* mss.

67. *The Tiger's Eye*, Number 8, page 41.

68. In pursuing their ideal of a "direct approach," the editors strove for the highest quality reproductions possible, but as a mag-azine, they still faced the challenge of neces-sarily trafficking in reproductions. One way they attempted to address this challenge was to separate the captions from the images.

69. One painting was used for the covers of Numbers 1 through 4, a second painting for Numbers 5 through 8, and a drawing in oil on paper for Number 9.

70. Mark Rothko to Ruth Stephan, June 24, 1947.

71. *The Tiger's Eye*, Number 2, p. 44.

72. *The Tiger's Eye*, Number 9, p. 72.

73. Ibid., Number 9, p. 114.

74. Eastern News Company order form, 1949. *TTE* mss.

75. Questionnaire sent by Marjorie Kimble of Syracuse University, March 8, 1949. Partially filled out by Ruth Stephan but never returned. See *TTE* mss.

76. Emeline K. Paige draft of publicity letter, July 9, 1947. See *TTE* mss.

77. Dorothea Tanning to Ruth Stephan, March 5, 1949.

78. Ibid.

79. Copies of *The Tiger's Eye*, Number 5, for example, were traded for copies of *The Southwest Review, Neurotica, New Mexico Quarterly Review, Cronos, Wake, Furioso, University of Kansas Review, The Sewanee Review, Quarterly Review of Literature, Caress Crosby Portfolio, Poetry, Perspective, Epoch, Accent*, and *Kenyon Review*. Foreign magazine exchanges for copies of the same issue included *Sur* (Argentina), *Mandrake* (Great Britain), *Inventario* (Italy), *Las Morades* (Peru), *Revista de la Biblioteca Nacional* (Central America), *Poesi* (Sweden), *France-Asie* (Indochine), and *Poetry* (Australia). Mailing list exchanges provided another way of tapping other publications' audiences. For example, *The Tiger's Eye* sent ten thou-sand promotional flyers to Circle Editions addressees in a trade that was specifically valuable as a way of expanding West Coast contacts. Correspondence between Paige and Leite, summer 1949.

80. Betty Parsons to *The Tiger's Eye*, November 12, 1948.

81. Newman memo to Stephans, n.d.

82. Alfred Barr to Ruth Stephan, September 30, 1947.

93. Letter from Mario Carreño to Stephans, November 29, 1948.

84. *TTE* mss.

85. *New York World Telegram*, December 9, 1948.

86. Ruth Stephan to Inez Boulton, February 8, 1949.

87. Donald Weismann to Ruth Stephan, n.d.

88. *The Tiger's Eye*, Number 9, page 38.

89. Howard Mitcham to John Stephan, January 30, 1950.

90. Vera Ellis Doane to Mr. and Mrs. Stephan, Christmas card, 1950.

91. Just the first few museums from the list of recipients, arranged alphabetically by city, demonstrates the range: Akron Art Institute, Albany Institute of History and Art, Addison Gallery of American Art, University of Michigan Museum of Art, Fine Arts Gallery of the University of Georgia, High Museum of Art, Cayuga Museum of History and Art, Auburn, N.Y.

92. Victoria Brown, Librarian, Anne Bremer Memorial Library, California School of Fine Arts to *The Tiger's Eye*, November 22, 1948.

93. Among the institutions benefiting from the college subscription fund were Illinois Wesleyan University, University of Alaska, Grinnell College, Carleton College, Tuskegee Institute, Black Mountain College, Bennett College, The New School, and Texas College of Arts and Industries.

94. Not surprisingly, some states were more thoroughly covered than others. For example, seventy-two bookstores in New York received copies, as did the same number in California. Fifty-nine bookstores in Illinois and fifty-four in Massachusetts received a promotional copy. And while only four Arizona stores and two Maine stores received copies, and only one each in North Dakota and South Dakota, there were plenty of surprisingly high numbers such as thirteen stores in Alabama and fourteen in Idaho.

95. *TTE* mss.

96. William Carlos Williams to Ruth Stephan, April 21, 1948.

97. John Nerber to Joseph Pope, Eastern News Company, September 30, 1948.

98. The December 1948 count broke down to 823 subscribers, 161 dealers in the United States, and 4 foreign dealers, for a total distribution of 2,714 copies. See *TTE* mss.

99. Ruth Stephan to bookstore clients, March 5, 1949.

100. Margueritte Harmon Bro to Ruth Stephan, n.d.

101. Ruth Stephan to Margueritte Harmon Bro, Wisconsin, June 10, 1950.

102. Elisabeth and Eddi Humbro to Ruth and John Stephan, letter stamped "received" February 17, 1950; and Ruth Stephan to Elisabeth and Eddi Humbro, June 1950.

103. Various correspondence, 1950.

104. Ruth Stephan to Vera Ellis Doane, March 10, 1950

105. Summer issue of *Imagi* and October issue of *The Writer*.

106. Terry Ishihara, *The Tiger's Eye* Secretary, to Robert Lee, October 18, 1950.

107. Postcard sent by *The Tiger's Eye* in response to inquiry from August H. Mason, University of Alabama, December 20, 1950.

108. Josef Albers, writing from Black Mountain College, to Mr. and Mrs. Stephan, June 4, 1949; Ruth Stephan sent note of acceptance June 8, 1950, and a check for $21.84 for approximately 1,092 words at 2 cents per word on June 15, 1950. His comments were on an exhibition of his work in January – February 1949.

109. Letter from John Stephan to Ben Tibbs, photographer, March 18, 1949.

110. Ruth Stephan to Max Bachhausen, Stuttgart-Sillenbuch, Germany, August 1, 1950.

111. Hadley School for the Blind, to *The Tiger's Eye*, April 12, 1950.

112. Letter to *The Tiger's Eye* from Library of Congress acknowledging gift, May 8, 1950.

113. Ruth Stephan to Frederick J. Hoffman, August 1, 1950.

114. Norman Holmes Pearson, Yale University Library, to Ruth Stephan, February 2, 1950.

115. The files arrived in 1958.

116. As of May 1951, inventory included 105 copies of Number 1; 509 copies of Number 2; 939 copies of Number 3; 754 of Number 4; 1,100 copies of Number 5; 828 copies of Number 6; 608 copies of Number 7; 622 copies of Number 8; and 200 copies of Number 9.

117. *The Tiger's Eye* to State Department, May 21, 1951.

118. Letters of this format sent to institutions on May 25, 28, 29, 31, and June 4, 1951. Sets of *The Tiger's Eye* went to institutions in Argentina, Australia, Austria, Belgium, Brazil, Canada, Czechoslovakia, Denmark, Finland, France, Germany, Russian zone, Great Britain, Ireland, Scotland, Wales, Greece, Hungary, Iceland, India, Pakistan, Iran, Israel, Italy, Japan, Mexico, The Netherlands, New Zealand, Norway, Peru, Philippines, Poland, Portugal, Spain, Sweden, Switzerland, Turkey, Egypt, Hawaii, Puerto Rico, Chile, Colombia, Dominican Republic, Equador, and Haiti.

119. The gift of the magazines had already been formally offered to and accepted by the United Negro College Fund through correspondence in May 1951.

120. Terry Ishihara to Werner Books, June 5, 1951.

121. Clement Greenberg, "Review of the Whitney Annual and the Exhibition *Artists for Victory*," *The Nation*, January 2, 1943. Reprinted in John O'Brian, ed., *Clement Greenberg: The Collected Essays and Criticism* (Chicago: University of Chicago Press, 1986–1993), vol. 2, p. 135. I am grateful to Gabrielle Gopinath for bringing Greenberg's remarks on Albright's painting to my attention.

122. *Ivan Albright,* (Chicago: The Art Institute of Chicago, 1997), cat. no. 24.

123. *The Tiger's Eye*, Number 3, p. 75, quoted earlier in this essay.

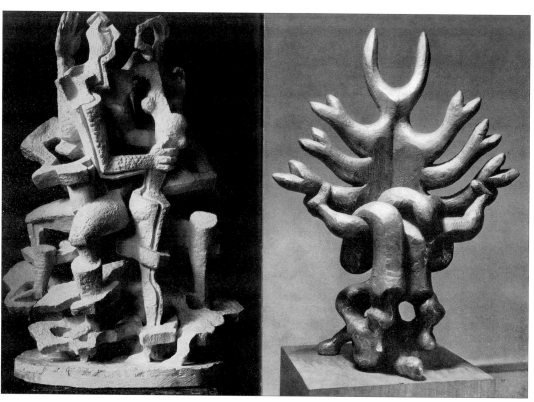

The Tiger's Eye, Number 4,
pages 90 and 91, showing
Ossip Zadkine, *The Birth of
Forms*, 1947 (left) and
Jacques Lipchitz, *Exodus*,
1947 (right)

Facing page:

*Herbert Ferber, *Apocalyptic
Rider*, 1947. Bronze, 44 ¹/₂ ×
38 × 25 in. Grey Art Gallery
and Study Center. New York
University Art Collection.
Anonymous gift
(*The Tiger's Eye* 4: 103)

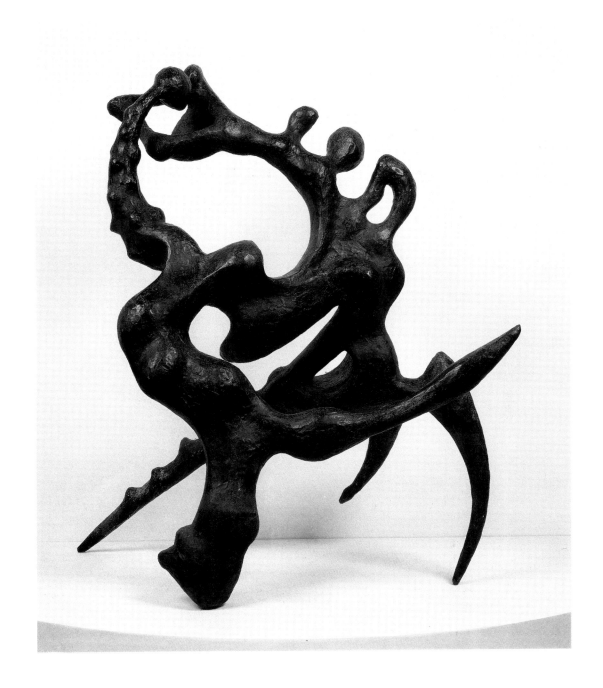

50

51

The Tiger's Eye, Number 9,
pages 50 and 51, showing
Jimmy Ernst, *Time for Fear*,
1949 (left) and Arshile
Gorky, *Soft Night*, 1948
and Paul Klee, *Moon over
a Town*, 1922 (right)

to be inspired. that is the thing.
to be possessed; to be bewitched;
to be obsessed. that is the thing.
to be inspired.

The Tiger's Eye, Number 5,
pages 54 and 55, showing
William Baziotes,
White Animals, 1947 (left)
and a statement by the
artist (right)

For the visual artists, a short bibliography is included. Because the artists range from eminent to unknown, sources listed vary widely in an attempt to situate each in the art world of the late 1940s. *The Tiger's Eye* provided short introductions to selected contributors in each issue's "Tale of the Contents." A part of this "tale" also follows below.

Block, Allan (1923–), 1:12–13, 5 (pamphlet)

The Exile and Weeds are by the young poet, Allan Block. He began writing poetry while on war service in India, and was published in a British anthology before he contributed to American magazines. (1:54)

Borges, Jorge Luis (1899–1986), 4:64–68

Very little of the imaginative Argentinian writer, Señor Borges, has been translated into English. This story was included in his book Ficciones. (4:71)

Borisoff, Paul (1895–1964), 7:77–78

Bosch, Hieronymous (Dutch, 1450–1516), 9:60–67

>Delvoy, Robert. *Hieronymous Bosch.* New York: Rizzoli International, 1990.

>Gibson, Walter S. *Hieronymous Bosch.* London: Thames and Hudson, 1989.

>Koldeweij, Jos, Paul Vandenbroeck and Bernard Vermet, eds. *Hieronymous Bosch: The Complete Paintings and Drawings* (exh. cat.). Rotterdam: NAi Publishers and Museum Boijmans Van Beuningen, and Ghent: Ludion, 2001.

Boultenhouse, Charles (1925–1996), 6:113–14

Bourgeois, Louise (American, 1911–), 7:91; 9:52

>Cole, Ian. *Louise Bourgeois* (exh. cat.). Oxford, England: Museum of Modern Art, 1995.

>Warner, Marina. *Louise Bourgeois* (exh. cat.). London: Tate Gallery Publishing, 2000.

>Wye, Deborah and Carol Smith. *The Prints of Louise Bourgeois* (exh. cat.). New York: Museum of Modern Art, 1994.

Branch, Doris B. (1918–1996), 2:27–29

There is a certain visualization of Picasso's paintings in these poems which alert readers may recognize. Miss Branch lives in Kansas. (2:63)

Brancusi, Constantin (French, b. Romania, 1876–1957), 4:93

>Bach, Friedrich Teja. *Constantin Brancusi 1876–1957* (exh. cat.). Philadelphia: Philadelphia Museum of Art, 1995.

>Hulten, Pontus. *Brancusi and the Concept of Sculpture.* New York: Harry N. Abrams, 1987.

>Miller, Sanda. *Constantin Brancusi: A Survey of His Work.* Oxford, England: Clarendon Press, 1995.

Braque, Georges (French, 1882–1963), 3:124

>Leymarie, Jean. *Georges Braque* (exh. cat.). New York: Solomon R. Guggenheim Foundation, 1988.

>Rubin, William. *Picasso and Braque: Pioneering Cubism* (exh. cat.). New York: Museum of Modern Art, 1989.

>Zurcher, Bernard. *Georges Braque: Life and Work.* New York: Rizzoli International, 1988.

Brinnin, John Malcolm (1916– deceased), 3:66–67; 4:48; 6:66, 131–42

Brooks, Van Wyck (1886–1963), 1:47–52

… whom a wide American public knows as a literary critic and historian. In 1923 Brooks wrote in a review for The Freeman *of a new edition of Melville that he was reading* Moby Dick *for the third time and wondered "if all its felicities have dawned even yet on people's minds." He believed, then, that Melville was a skillful craftsman who found only once a subject which suited his talent. "But," he concluded, "his masterpiece is worth more than libraries of lesser books.* Moby Dick *is our sole American epic, no less an epic for being written in prose." The present account is from* The Times of Melville and Whitman *to be published by E. P. Dutton and Co., Inc., New York, on October 31st.* (1:55)

Burke, Mary Louise (1916–), 6:105

Byrd, Richard Evelyn (1887–1957), 9:22

Cage, John (1912–1992), 7:52–56

… famous for his "prepared piano" music, is one of the most brilliant of the new composers. He says this article is "a concentration of about all that I am aware of at this time." (7:59)

Cahoon, Herbert (1918–2000), 1:93–100; 2:84–88; 4:109–18; 6:99–102; 8:128–38; 9:8–9, 135–42

In addition to composing many of his own, Herbert Cahoon has made a study of verse drama.

Calas, Nicholas (1907–1989), 3:112–14; 6:53–56

Calder, Alexander (American, 1898–1976), 4:74, 99

>Lipman, Jean. *Calder's Universe* (exh. cat.). New York: Whitney Museum of American Art, 1976.

>Marter, Joan M. *Alexander Calder.* Cambridge, England: Cambridge University Press, 1991.

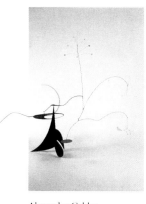

Alexander Calder, *Bougainvillier*, 1947. Sheet metal, wire, lead and paint, 78 ¹/₂ × 86 in. Private collection. (*The Tiger's Eye* 4:99)

Prather, Marla. *Alexander Calder, 1898–1976* (exh. cat.). Washington, D.C.: National Gallery of Art and New Haven: Yale University Press, 1998.

Callery, Mary (American, 1903–1977), 4:74–75, 88

Mary Callery (exh. broch.). New York: Buchholz Gallery, 1950.

Mary Callery: Recent Sculpture, 1944–1947 (exh. broch.). New York: Buchholz Gallery, 1947.

Mary Callery: Sculpture. New York: Wittenborn and Co., 1961.

Campbell, Joseph (1904–1987), 7:24–26

Carreño, Mario (Chilean, b. Cuba, 1913–), 2:37–41, 45

Carreño is a Cuban who has traveled and painted in Spain and France. He has been a resident in the United States for the last few years, where his paintings have been widely noticed and appreciated. The forthcoming year he expects to spend in Chile.

Mario Carreño (exh. cat.). Santiago: Ediciones Galería Imagen, 1976.

Mario Carreño: A Retrospective: Sotheby's Latin American Paintings, January 4–January 6, 1995 (exh. broch.). Coral Gables, Fla.: Sotheby's, 1995.

Mario Carreño, 80 Dibujos, una colección en su aniversario numero ochenta (exh. cat.). Santiago: Instituto Cultural de Las Condes, 1993.

Carrier, Warren (1918–), 4:14–28

Chagall, Marc (Russian, 1887–1985), 6:17

Baal-Teshuva, Jacob. *Chagall.* Cologne: Taschen, 1998.

Compton, Susan P. *Marc Chagall, My Life, My Dream: Berlin and Paris, 1922–1940.* Munich: Prestel, 1990.

Doschka, Roland. *Marc Chagall: Origins and Paths.* Munich: Prestel, 1998.

Char, René (1907–1988), 9:33–35

Chew, H. Richard (ca. 1922–), 2:18

Chirico, Giorgio de (Italian, 1888–1978), 3:94, 96

Baldacci, Paolo. *Giorgio de Chirico: Betraying the Muse.* New York and Milan: Paolo Baldacci, 1994.

Braun, Emily. *Giorgio de Chirico and America* (exh. cat.). New York: Hunter College of the City University of New York, 1996.

Soby, James Thrall. *Giorgio de Chirico.* New York: Published for the Museum of Modern Art by Arno Press, 1966. Revision of *The Early Chirico*, New York: Museum of Modern Art, 1941.

Chuang Tzu, 4:108

Clements, Albert, 3:10

Cloud, Jess (1917–1979), 7:72

Coates, Carrol (1905–1985), 4:109–18

Cole, Thomas (1922–), 2:35; 7:30–31; 9:97

Coleman, Lucille, 3:88

Cook, Albert Spaulding (1925–), 7:3

Crews, Judson Campbell (1917–), 7:7

De Gamboa, Pedro Sarmiento (ca. 1532–1592), 5:122

De Groot, Nanno (Dutch, 1913–1992), 8:31, 58–59; 9

Exhibitions:

1951: Bertha Schaefer Gallery, New York; Saidenberg Gallery, New York

1953: Saidenberg Gallery, New York

1958: Parma Gallery, New York

1959: Parma Gallery, New York

De Kooning, Willem (American, b. Netherlands, 1904–1997), 3:101

Cummings, Paul. *Willem de Kooning: Drawings, Paintings, Sculpture* (exh. cat.). New York: Whitney Museum of American Art, 1983.

Prather, Marla. *Willem de Kooning: Paintings* (exh. cat.). Washington, D.C.: National Gallery of Art, 1994.

Yard, Sally. *Willem de Kooning: The First Twenty-Six Years in New York, 1927–1952.* New York: Garland, 1986.

DeJong, David Cornel (1905–1967), 1:9–10; 5:32–38

Delvaux, Paul (Belgian, 1897–1994), 6:18

Leen, Frederik and Gisèle Ollinger-Zinque. *Paul Delvaux 1897–1994: Royal Museums of Fine Arts of Belgium, Brussels* (exh. cat.). Wommelgem: Blondé, 1997.

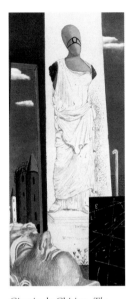

Giorgio de Chirico, *The Endless Voyage*, 1914. Oil on canvas, 34 $^{15}/_{16}$ × 15 $^{11}/_{16}$ in. The Wadsworth Atheneum Museum of Art, Hartford, Conn., The Phillip L. Goodwin Collection (*The Tiger's Eye* 3:94)

Ferber, Herbert (American, 1906–1991), 2:44; 4:75–76, 103
> Agee, William C. *Herbert Ferber: Sculpture, Painting, Drawing: 1945–1980.* Houston:
> > Museum of Fine Arts, 1983.
> Goossen, E. C. *Herbert Ferber.* New York: Abbeville Press, 1981.
> Verderame, Lori. *The Founder of Sculpture as Environment: Herbert Ferber (1906–1991)*
> > (exh. cat.). Hamilton, N.Y.: Picker Art Gallery, Colgate University, 1998.

Flannagan, John B. (American, 1895–1942), 4:86
> *John B. Flannagan, Sculpture/Drawings, 1924–1938* (exh. cat.). Saint Paul:
> > Minnesota Museum of Art, 1973.
> *A Memorial Exhibition of the Sculpture of John Flannagan* (exh. cat.). Richmond:
> > Virginia Museum of Fine Arts, 1946.
> Miller, Dorothy C., ed. *The Sculpture of John B. Flannagan* (exh. cat.). New York:
> > Museum of Modern Art, 1942.

Flynn, Patrick, Jr., 3:4

Ford, Charles Henri (b. 1913), 7:87–88
Noted as the editor of View, *Charles Ford devotes his time to writing since the cessation of the magazine.* (7:60)

Fowlie, Wallace (1908–), 7:9–23

Frankenberg, Lloyd (1907–1975), 1:43–44; 7:116–27; 8:14–16; 9:25–32
… who was also a conscientious objector during the war. He has been the happy recipient of several awards for his poetry and essays, the latest being a grant from the American Academy of Arts and Letters for his work in progress, Meanings in Modern Poetry. (1:55)

Naum Gabo, *Linear Construction in Space No. 1, Variation*, 1942–43 (fabricated ca. 1957–58). Plexiglas with nylon micro-filament, 24 $^{13}/_{16}$ × 24 $^{13}/_{16}$ × 9 $^{1}/_{2}$ in. The Patsy R. and Raymond D. Nasher Collection, Dallas, Tex. (earlier version *The Tiger's Eye* 4:97)

Frasconi, Antonio (American, b. Argentina, 1919–), 8:18, 59–61
> *The Books of Antonio Frasconi: A Selection, 1945–1995* (exh. cat.). With texts by
> > Robert D. Graff and Margaret K. McElderry. New York: The Grolier Club, 1996.
> *Frasconi: Against the Grain, The Woodcuts of Antonio Frasconi.* With texts by Nat Hentoff
> > and Charles Parkhurst. New York: Collier, 1974.
> Prasse, Leona E. *The Work of Antonio Frasconi* (exh. cat.). Cleveland: Cleveland Museum
> > of Art, 1952.

Frechtman, Bernard (d. 1967), 6:33–40; 7:93–115; 8:99–100

Frimet, Hillel, 9:106–108

Fung, Yu-lan (1895–1990), 4:108

Gabo, Naum (Russian, 1890–1977), 4:97
> Hammer, Martin and Christina Lodder. *Constructing Modernity: The Art and Career of
> > Naum Gabo.* New Haven: Yale University Press, 2000.
> Nash, Steven A. and Jörn Merkert, eds. *Naum Gabo: Sixty-Years of Constructivism:
> > Including Catalogue Raisonné of the Constructions and Sculptures* (exh. cat.).
> > Munich: Prestel, 1985.
> *Naum Gabo, the Constructive Idea: Sculpture, Drawings, Paintings, Monoprints* (exh. cat.).
> > London: South Bank Board, 1987.

Garai, Pierre, 8:84–87

Garrigue, Jean (1914–1972), 9:117–22

Gatch, Lee (American, 1902–1968), 6:31
> Breeskin, Adelyn D. *Lee Gatch 1902–1968* (exh. cat.). Washington, D.C.: National
> > Collection of Fine Arts, Smithsonian Institution, 1971.
> *Lee Gatch: The Phillips Collection, January 23–March 27, 1988* (exh. broch.).
> > Washington, D.C.: Phillips Collection, 1988.
> Rathbone, Perry T. *Lee Gatch* (exh. cat.). New York: American Federation of Arts, 1960.

Genet, Jean (1910–1986), 8:99–100; 9:1–6
Called, by Sartre, the latest and greatest of the "black magic" writers, and, by Cocteau, a great poet who "is the psychologist of people who do not think and whose darkness lies outside the very pure night which inhabits them," Genet is the most discussed young genius in Paris. His book Our Lady of the Flowers, *from which this piece was taken, combines the novel and autobiography.* (8:76)

Ghiselin, Brewster (1903–), 3:11; 4:109–18

Giacometti, Alberto (Swiss, 1901–1966), 4:76–78, 85; 7:63
> *Alberto Giacometti: Exhibition of Sculptures, Paintings, Drawings* (exh. cat.). New York:
> > Pierre Matisse Gallery, 1948.
> Bonnefoy, Yves. *Alberto Giacometti: A Biography of His Work.* Paris: Flammarion, 1991.
> Fletcher, Valerie J. *Alberto Giacometti 1901–1966* (exh. cat.). Washington, D.C.:
> > Hirshhorn Museum and Sculpture Garden, Smithsonian Institution, 1988.

*Ian Hugo, *African Dream*, from the portfolio *This Hunger*, 1945. Wood engraving, composition: 7 × 5 ¼ in.; sheet: 7 ⅞ × 6 in. Brooklyn Museum of Art, Gift of Mr. W. S. Heiman

Russotto, Ellen. *A Tribute to David Hare 1917–1992* (exh. broch.). New York: New York Studio School, 1994.

Hauser, Marianne (1910–), 3:21–34; 5:69–70; 8:88–98

Hayakawa, Samuel Ichiye (1906–1992), 9:132–34

Hayden, Robert Earl (1913–1980), 4:36

Hays, Hoffman Reynolds (1904–1980), 4:64–68; 5:112–21

Hayter, Stanley William (British, 1901–1988), 1:73; 3:103; 7:66; 8:17, 41–45; 9:56

> Black, Peter and Desirée Moorhead. *The Prints of Stanley William Hayter*. Mount Kisco, N.Y.: Moyer Bell Limited, 1992.
>
> Esposito, Carla. *Hayter e l'Atelier 17*. Milan: Electa, 1990.
>
> Hacker, P.M.S. *The Renaissance of Gravure: The Art of S. W. Hayter*. Oxford, England: Clarendon Press, 1988.
>
> Moser, Joann. *Atelier 17* (exh. cat.). Madison: Elvejem Art Center, University of Wisconsin, 1977.

Hecht, Joseph (Polish, 1891–1951), 8:21

> Armentrout, J. Michael. *Joseph Hecht* (exh. cat.). Philadelphia: Dolan/Maxwell Gallery, 1985.
>
> Tonneau-Ryckelynck, Dominique and Roland Plumart. *Joseph Hecht: Catalogue raisonné de l'oeuvre gravé*. Gravelines, France: Éditions du Musée de Gravelines, 1992.
>
> Wilker, Jenny Squires. "Joseph Hecht: Animalier-Buriniste." *The Print Collector's Newsletter* 22 (September/October 1991), pp. 126–31.

Higdon, Grace. 6:112

Hokusai (Japanese, 1760–1849), 2:79

> Forrer, Matthi. *Hokusai: Prints and Drawings*. Munich: Prestel, 1991.
>
> Lane, Richard. *Hokusai: Life and Work*. New York: E. P. Dutton, 1989.
>
> Nagata, Seiji. *Hokusai: Genius of the Japanese Ukiyo-e*. Tokyo and New York: Kodansha International, 1995.

Holden, Harold, 5:5

Holzhauer, Robin, 5:10

Honig, Edwin (1919–), 9:83–96

Hoskins, Katherine (1909–1988), 8:9

Hugo, Ian (Hugh P. Guiler, American, b. France, 1899–1985), 1:5–6

The four engravings inserted among the poems are by Ian Hugo, who is known for his experiments in graphic technique. He is the author of the recently published New Eyes On The Art Of Engraving. *(1:54)*

> "Hugh Guiler, a Banker and Short–Film Maker." *New York Times* [obituary], 11 January 1985.
>
> Hugo, Ian. *New Eyes on the Art of Engraving: An Essay and Method*. Yonkers, N.Y.: Alicat Book Shop Press, 1946.
>
> Walker, John. "A Seven-Minute Epic Caps His Career." *International Herald Tribune*, 14 September 1970.

James, Grace, 2:70–73

James, Henry (1843–1916), 1:36–39

Johnson, Una E. (1906–1997), 8:62–63

Kamrowski, Gerome (American, 1914–), 3:105

> Breton, André. *Peintures de Kamrowski* (exh. broch.). Paris: Galerie R. Creuze, 1950.
>
> *Gerome Kamrowski: The 1940s* (exh. broch.). With an interview by John Yau. New York: Washburn Gallery, 1989.
>
> Maurer, Evan M. and Jennifer L. Bayles. *Gerome Kamrowski: A Retrospective Exhibition* (exh. cat.). Ann Arbor: University of Michigan Museum of Art, 1983.

Kandinsky, Wassily (Russian, 1866–1944). 7:81

> Hahl-Koch, Jelena. *Kandinsky*. New York: Rizzoli International, 1993.
>
> Messer, Thomas H. *Vasily Kandinsky*. New York: Harry N. Abrams, 1997.
>
> Roethel, Hans K. and Jean K. Benjamin. *Kandinsky: Catalogue Raisonné of the Oil Paintings* (6 vols.). Ithaca, N.Y.: Cornell University Press, 1982–84.

Kavafis, Kostas P. (1863–1933), 3:85–87

Kees, Weldon (1914–1955), 2:20; 5:1–2, 71–72

Kelly, Leon (American, 1901–1982), 2:21–22

Leon Kelly is a native of Philadelphia. He began studying painting under Jean Auguste Adolph in

*Ian Hugo, *Dawn*, from the portfolio *This Hunger*, 1945. Wood engraving, composition: 8 × 6 in.; sheet: 8 ⅞ × 6 ⅞ in. Brooklyn Museum of Art, Gift of Mr. W. S. Heiman

1914, went on to the Pennsylvania Academy of Fine Arts, and, in 1924, to Europe where he worked, mainly, with the "School of Paris" men until 1930. He uses all mediums for his work. (2:62)

 Leon Kelly: American Surrealist (exh. cat.). New York: Berry-Hill Galleries, Inc., 1999.

 Leon Kelly (exh. broch.). New York: Washburn Gallery, 1981.

 Leon Kelly: Retrospective Exhibition, 1920–1964 (exh. cat.). Baltimore: International Gallery, 1964.

Klee, Paul (Swiss, 1879–1940), 7:71; 9:51

 Comte, Philippe. *Paul Klee.* Woodstock, N.Y.: Overlook Press, 1991.

 Helfenstein, Josef and Christian Rumelin. *Catalogue Raisonné: Paul Klee* (4 vols.). Bern: Paul Klee Foundation and Kunstmuseum Bern, 1998–2000.

 Lanchner, Carolyn. *Paul Klee* (exh. cat.). New York: Museum of Modern Art, 1987.

Klein, Medard (American, b. 1905), 8:26

Kochnitzky, Leon A. (1894–deceased), 1:77–81; 3:59–65; 5:62–67; 8:139; 9:73–82

Kohn, Misch (American, 1916–), 8:20

 Hernandez, Joanne Farb. *Misch Kohn: Beyond the Tradition* (exh. cat.). Monterey, Calif.: Monterey Museum of Art, 1998.

 Metz, Kathryn. *Misch Kohn: Three Decades of Printmaking* (exh. broch.). Santa Cruz: Eloise Pickard Smith Gallery, Cowell College, University of California-Santa Cruz, 1981.

 Zigrosser, Carl. *Misch Kohn* (exh. cat.). New York: American Federation of Arts, 1961.

Krim, Seymour (1922–1989), 5:17–31; 9:126–28

Lam, Wifredo (Cuban, 1902–1982), 6:23; 9:45

 Balderrama, Maria R., ed. *Wifredo Lam and His Contemporaries, 1938–1952* (exh. cat.). New York: Studio Museum in Harlem, 1992.

 Fouchet, Max-Pol. *Wifredo Lam.* Barcelona: Ediciones Polígrafa, 1976.

 Laurin-Lam, Lou. *Wifredo Lam: Catalogue Raisonné of the Painted Work.* Lausanne: Éditions Acatos, 1996.

Lamantia, Philip (1927–), 5:15

Laughlin, James (1914–1977), 9:36

Laurens, Henri (French, 1885–1954), 4:89

 Henri Laurens: Bronzes, Collages, Drawings, Prints (exh. cat.). London: Arts Council of Great Britain, 1980.

 Henri Laurens: Rétrospective (exh. cat.). Paris: Réunion des musées nationaux and Villeneuve-d'Ascq: Musée d'art moderne Villeneuve-d'Ascq, 1992.

 The Sculpture of Henri Laurens. New York: Harry N. Abrams, 1970.

Lautréamont, Comte de [Isidore Ducasse] (1846–1870), 9:20–21

Lawson, John S., 4:54–55

Leonid (American, 1896–1976), 2:79

 Berman, Leonid. *The Three Worlds of Leonid.* New York: Basic Books, 1978.

 Leonid and His Friends: Tchelitchew, Berman, Bérard. New York: New York Cultural Center, 1974.

 Kochnitzky, Leon. "Leonid Paints a Picture." *Art News* 49 (May 1950), pp. 41–43.

 Myers, John Bernard. "Leonid and the Neo-Romantics." *Art in America* 67 (October 1979), pp. 110–13.

Libert, Jack (1913–1974), 3:39–51

Lipchitz, Jacques (French, 1891–1973), 4:80, 91

 Hammacher, A. M. *Jacques Lipchitz.* New York: Harry N. Abrams, 1975.

 Wilkinson, Alan G. *Jacques Lipchitz: A Life in Sculpture* (exh. cat.). Toronto: Art Gallery of Ontario, 1989.

 Wilkinson, Alan G. *The Sculpture of Jacques Lipchitz: A Catalogue Raisonné.* London: Thames and Hudson, 1996.

Lippold, Richard (American, 1915–1985), 4:79–80, 98

 "An Artist's Point of View." *Architectural Record* 164 (December 1978), pp. 69–71.

 Carter, Curtis L., Jack W. Burnham and Edward Lucie-Smith. *Richard Lippold: Sculpture.* Milwaukee: Marquette University, 1990.

 "Richard Lippold." *Quadrum* 14 (1963), pp. 35–46, 191.

Lipton, Seymour (American, 1903–1986), 4:80, 104

 Elsen, Albert. *Seymour Lipton.* New York: Harry N. Abrams, 1970.

 Rand, Harry. *Seymour Lipton: Aspects of Sculpture* (exh. cat.). Washington, D.C.: National Collection of Fine Arts, Smithsonian Institution, 1979.

*Ian Hugo, *Tree Woman,* from the portfolio *This Hunger,* 1945. Wood engraving, composition: 8 × 6 in.; sheet: 9 × 7 1/16 in. Brooklyn Museum of Art, Gift of Mr. W. S. Heiman

Verderame, Lori. *An American Sculptor: Seymour Lipton* (exh. cat.). University Park, Penn.: Palmer Museum of Art, 1999.

Lye, Len (1901–1980), 7:67–68

... is a native of New Zealand. His earlier career is marked by the beautiful designs of books he made while living in Majorca and which contained, among others, the poetry of Laura Riding and Robert Graves. The gayety of his imagination is applied now to living in New York next door to Hayter, and to experimental films and philosophy. (7:59)

MacIver, Loren (American, 1909–1998), 6:26; 9:58

Frash, Robert M. *Loren MacIver: Five Decades* (exh. cat.). Newport Beach, Calif.: Newport Harbor Art Museum, 1983.

Garbrecht, Sandra. *Loren MacIver: The Painter and the Passing Stain of Circumstance.* Washington, D.C.: Georgetown University Press, 1987.

Loren MacIver: A Retrospective (exh. cat.). New York: Tibor de Nagy Gallery, 1998.

Maclaine, Christopher, 8:101–110

Magritte, René (French, 1898–1967), 2:78; 7:85

Leen, Frederick and Gisèle Ollinger-Zinque. *Magritte 1898–1967* (exh. cat.). Brussels: Royal Museums of Fine Arts of Belgium, 1998.

Sylvester, David. *Magritte: The Silence of the World.* New York: Harry N. Abrams, 1992.

———. *René Magritte: Catalogue Raisonné* (5 vols.). London: Philip Wilson Publishers/The Menil Foundation, 1992.

Manheim, Ralph (1907–1992), 2:6–16; 3:35–38; 7:39–40

Margo, Boris (American, 1902–1995), 2:42–43; 6:31; 8:23, 53–55; 9:45

Boris Margo: A Retrospective (exh. broch.). Provincetown, Mass.: Provincetown Art Association and Museum, 1988.

Schmeckebier, Laurence. *Boris Margo: Graphic Work, 1932–1968.* Syracuse, N.Y.: School of Art, Syracuse University, 1968.

Wechsler, Jeffrey. "Boris Margo: Experiment and Innovation." *Arts Magazine* 52 (December 1977), pp. 88–92.

Martinelli, Ezio (American, 1913–1980), 8:38

Solo exhibitions:

1946, 1947, 1952, 1956, 1959, 64–65: Willard Gallery, New York

Masson, André (French, 1896–1987), 3:99; 8:24, 56–58; 9:46

Masson l'insurgé du XXème siècle. Rome: Edizioni Carte Segrete, 1989.

Rubin, William and Carolyn Lanchner. *André Masson* (exh. cat.). New York: Museum of Modern Art, 1976.

Saphire, Lawrence. *André Masson: Catalogue raisonné des livres illustrés.* Geneva: Patrick Cramer, 1994.

Matta (Roberto Sebastián Antonio Echaurren Matta) (Chilean, b. 1911), 3:97; 6:26

Matta (exh. cat.). Madrid: Museo Nacional Centro de Arte Reina Sofía, 1999.

Miller, Nancy. *Matta: The First Decade* (exh. cat.). Waltham, Mass.: Rose Art Museum, Brandeis University, 1982.

Rubin, William. *Matta* (exh. cat.). New York: Museum of Modern Art, 1957.

Mayhall, Jane Francis (1921–), 9:10

Mayo Edward Leslie (1904–), 6:103

McElroy, Walter, 9:33–35

McLaughlin, Richard, 1:45–46

... who has met existentionalism and existentialists in several European countries. He received part of his education abroad and was an overseas U.S. army correspondent. Now he is back, writing an allegory of the battle between good and evil today. (1:55)

Merton, Thomas (1915–1968), 1:1; 6:41–45

The Landfall is by a Trappist monk, known to poetry readers as Thomas Merton, who leads a contemplative life in an abbey in Kentucky. He describes the aesthetic experience as a "supra-rational intuition of the latent perfection of things," and poetry as 'a very high gift, though only in the natural order" that has the merit of "communicating some idea of the delights of contemplation." (1:54)

Michaux, Henri (1899–1984), 1:90–92

Miró, Joan (Spanish, 1893–1983), 1:75; 6:22; 8:22

Dupin, Jacques and Ariane Lelong-Mainaud. *Joan Miró: Catalogue Raisonné. Paintings.* Paris: Daniel Lelong–Successió Miró, 1999.

Dupin, Jacques. *Miró Engraver* (3 vols.). New York: Rizzoli International, 1989.

Joan Miró: A Retrospective (exh. cat.). New York: Solomon R. Guggenheim Foundation and New Haven: Yale University Press, 1987.

Mitcham, Howard (1922–1996), 9:38–43

Mohn, Earl (1913–1996), 7:80

Moir, Robert (American, 1917–1986), 4:106

Moore, George, 3:140

Moore, Henry (British, 1898–1986), 4:87

 Mitchinson, David and Julian Stallabrass. *Henry Moore.* New York: Rizzoli International, 1992.

 Seldis, Henry J. *Henry Moore in America.* New York: Praeger Publishers, 1973.

 Sylvester, David. *Henry Moore: Complete Sculpture.* London: Lund Humphries, 1988.

Moore, Marianne (American, 1887–1972), 1:21–35

In the Selections from A Poet's Reading Diary And Sketchbooks *the photographs of the pages from the diary are approximately actual size while those of the sketchbooks have been reduced. All the photographs were taken by Aaron Siskind. The Tiger's Eye is aware of Marianne Moore's graciousness in permitting her notebooks to be introduced in its first issue for, as editor of* The Dial *as well as through her poetry, Miss Moore has achieved a unique place in the literary world. Her poem "The Mind Is An Enchanting Thing" is from her book* Nevertheless. *New York: Macmillan, 1944.* (1:54)

 Willis, Patricia C. *Marianne Moore: Vision into Verse.* Philadelphia: Rosenbach Museum and Library, 1987.

Morgan, Maud (American, 1903–1999), 6:30

 Maud Morgan: A Retrospective Exhibition, 1927–1977 (exh. cat.). Andover, Mass.: Addison Gallery of American Art, Phillips Academy, 1977.

 "Maud Morgan: Woman with a Purpose." *Art News* 41 (October 1942), p. 25.

 Morgan, Maud. *Maud's Journey: A Life from Art.* Berkeley, Calif.: New Earth, 1995.

 Rudkin, Mark. *Painter's Departure: Current Trends as Reflected in the Paintings of Maud Morgan* (exh. broch.). New Haven: Yale University Art Gallery, 1951.

Morton, Bert, 8:120–27

Moss, Stanley (1925–), 5:13

Motherwell, Robert (American, 1915–1991), 3:95; 6:24, 46–48

 Arnason, H. H. Robert Motherwell. New York: Harry N. Abrams, 1982.

 Motherwell (exh. cat.). Barcelona: Fundació Antoni Tapies, 1996.

 Terenzio, Stephanie. *The Prints of Robert Motherwell: A Catalogue Raisonné 1943–1984* (exh. cat.). New York: Hudson Hills Press in association with the American Federation of Arts, 1991.

Murch, Walter Tandy (American, 1907–1967), 4:42–47

Walter Murch has been illuminated by the realism of the early Dutch and Italian masters, as well as by Chardin and Pierre Roy. He studied first at the Ontario College of Art under Arthur Lismer, one of the "Group of Seven," later came to New York and studied with H. K. Miller at the Art Students League, and Arshile Gorky at the Grand Central Art School. Since 1933 he has worked at industrial design and mural paintings with architects in New York. He was born in Toronto, Canada. (4:71)

 Collischan Van Wagner, Judy. *Walter Murch: Major Paintings* (exh. cat.). New York: Sid Deutsch Gallery, 1987.

 ———. *Walter Murch: Paintings and Drawings* (exh. cat.). Greenvale, N.Y.: Hillwood Art Gallery, Long Island University, 1986.

 Walter Murch: A Retrospective Exhibition (exh. cat.). Providence: Museum of Art, Rhode Island School of Design, 1966.

Murray, Philip (1924–), 2:69; 4:33–35

Neiman, Gilbert (1912–1977), 5:11

Nerber, John (1915–1968), 2:36, 101–116; 6:63, 131–40

Neruda, Pablo (1904–1973), 5:112–21

Newman, Barnett B. (American, 1905–1970), 1:57–60; 2:43; 3:101, 111; 6:28, 51–53; 9:59, 122–26

… a painter and a spokesman for contemporary painting, who has also arranged exhibits of primitive art. He has been singled out by traditionalists as a man to watch (or to watch out for) because of his cognizance of the changing forms in art. (1:55)

 Hess, Thomas B. *Barnett Newman* (exh. cat.). New York: Museum of Modern Art, 1971.

 O'Neill, John P. *Barnett Newman: Selected Writings and Interviews.* New York: Alfred A. Knopf, 1989.

An artist paints so that he will have something to look at; at times he must write so that he will also have something to read.

Barnett B. Newman
(*The Tiger's Eye* 2:43)

Molinari, Danielle, Marie-Claire Anthonioz, and Guillaume Garnier, *Georges Rouault, 1871-1958: Catalogue raisonné*. Paris: Musée d'art moderne de la ville de Paris, 1983.

Ryan, Anne (American, 1889–1954), 8:39, 55–56; 9:37

 Armand, Claudine. *Anne Ryan Collages* (exh. cat.). Giverny: Musée d'art Américain and Terra Foundation for the Arts, 2001.

 Faunce, Sarah. *Anne Ryan Collages*. Brooklyn: Brooklyn Museum, 1974 and Washington, D.C.: National Collection of Fine Arts, Smithsonian Institution, 1974.

 Solomon, Deborah. "The Hidden Legacy of Anne Ryan." *The New Criterion* 7, 5 (January 1989), p. 13.

Sage, Kay (American, 1922–1989), 2:67

 A Tribute to Kay Sage, 1898-1963 (exh. cat.). Waterbury, Conn.: Mattatuck Museum, 1965.

 Miller, Stephen Robeson. "In the Interim: the Constructivist Surrealism of Kay Sage." *Surrealism and Women,* eds. Mary Ann Caws, Rudolf E. Kuenzli, Gwen Raaberg. Cambridge, Mass.: MIT Press, 1991.

 ———. "The Surrealist Imagery of Kay Sage." *Art International* 26 (September/October 1983), pp. 38, 40.

 Suther, Judith D. *A House of Her Own: Kay Sage Solitary Surrealist.* Lincoln: University of Nebraska Press, 1997.

Sappho (6th Century, B.C.), 3:1

Schanker, Louis (American, 1903–1981), 8:33, 45–47

 Johnson, Una E. *Louis Schanker: Prints 1924–1971* (exh. cat.). Brooklyn, N.Y.: Brooklyn Museum, 1974.

 Louis Schanker: Prints and Drawings (exh. cat.). New York: Associated American Artists, 1986.

 Schanker (exh. broch.). New York: Dorsky Gallery, 1966.

Schevill, James Erwin (1920–deceased), 6:73

Schnabel, Day (American, b. Austria, 1905), 4:105

 Day Schnabel (exh. broch.). New York: Mortimer Brandt Gallery, 1946.

 Day Schnabel: Recent Sculpture (exh. broch.). New York: Betty Parsons Gallery, 1951.

Schrag, Karl (American, 1912–1996), 9:44

 Gordon, John. *Karl Schrag* (exh. cat.). New York: American Federation of Arts, 1960.

 Johnson, Una E. *Karl Schrag: A Catalogue Raisonné of the Graphic Works 1939–1970.* Syracuse, N.Y.: School of Art, Syracuse University, 1971.

 McAvoy, Suzette Lane. *Karl Schrag: A Retrospective Exhibition* (exh. cat.). Rockland, Maine: Farnsworth Art Museum, 1992.

 Prints by Karl Schrag: January 7–February 21, 1972 (exh. cat.). Washington, D.C.: National Collection of Fine Arts, Smithsonian Institution, 1972.

Schwartz, Selwyn (1907–1988), 4:41

Schwitters, Kurt (German, 1887–1948), 8:29

 Dietrich, Dorothea. *The Collages of Kurt Schwitters: Tradition and Innovation.* Cambridge, England: Cambridge University Press, 1993.

 Elderfield, John. *Kurt Schwitters.* London: Thames and Hudson, 1985.

 Orchard, Karin and Isabel Schulz. *Kurt Schwitters: Catalogue Raisonné.* Hannover: Sprengel Museum, 2000.

Sekula, Sonia (Swiss, 1918–1963), 6:27

 Foote, Nancy. "Who Was Sonia Sekula?" *Art in America* 59 (September 1971), pp. 73–80.

 Glueck, Grace. "A Golden Girl Escaping Into Infinity." *New York Times,* 20 September 1996, p. C24.

 Schwarz, Dieter. *Sonja Sekula, 1918–1963* (exh. cat.). Winterthur: Kunstmuseum Winterthur, 1996.

Seldon, Edwin S. (1917–1984), 4:118; 5:130–34; 6:140–42; 9:140–42

Seligmann, Kurt (American, b. Switzerland, 1900–1962), 6:46, 87–92; 9:48, 61–67

Born in Basle, Switzerland in 1900, Kurt Seligmann studied and worked in France and Italy, and exhibited extensively in Europe, Mexico, Japan, and, since 1939, in the United States. He is a painter, engraver, stage designer and author. Having participated since its foundation in 1932 in the movement Abstraction-Creation, Seligmann joined the Surrealists in 1938. In 1945 he rejected the orthodox postulate "psychic pure automatism" to which he opposed "a chance image transformed by reason." (6:60) . . . He is the author of The Mirror of Magic. *(9:72)*

Hauser, Stephan E. *Kurt Seligmann 1900–1962: Leben und Werk.* Basel: Schwabe and Co., 1997.

Kurt Seligmann: His Graphic Work (exh. cat.). New York: Helen Serger, La Boetie, 1973.

Mason, Rainer Michael. *Kurt Seligmann: oeuvre gravé.* Geneva: Éditions du Tricorne, 1982.

Shakespeare, William (1564–1616), 2:66

Shelley, Robert (1927–), 7:84

Simon, John G. (1928–), 3:12–13

Siskind, Aaron (1903–1991), 1:21, 23–29, 31–35

Smith, David (American, 1906–1965), 4:81–82, 100

Krauss, Rosalind E. *The Sculpture of David Smith: A Catalogue Raisonné.* New York: Garland, 1977.

Marcus, Stanley E. *David Smith: The Sculptor and His Work.* Ithaca, N.Y.: Cornell University Press, 1983.

Wilkin, Karen. *David Smith, the Formative Years* (exh. cat.). Edmonton: Edmonton Art Gallery, 1981.

Smith, William Jay (1918–), 2:17; 4:52–53

Solomon, Marvin, 6:107

Spender, Sir Stephen (1909–1995), 4:1–13

Stafford, William E. (1914–1993), 1:11

… a native Kansan poet living in Claremont, California. He is a conscientious objector to war, and, as such, spent four years in the U.S. Forest Service and the Soil Conservation Service. (1:54)

Stamos, Theodoros (American, 1922–1997), 2:43, 68, 77; 3:79, 99

*Theodoros Stamos, *Divining Rod*, 1949. Monotype, 13 × 9 ½ in. Collection of William Mandel, B.F.A. 1953, and Robert Russell, M.A. 1954

Cavaliere, Barbara. *Theodoros Stamos: An Overview* (exh. cat.). New York: ACA Galleries, 1992.

Kafetski, Anna. *Theodoros Stamos, 1922–1997: A Retrospective* (exh. cat.). Athens, Greece: National Gallery and Alexandros Soutzos Museum, 1997.

Pomeroy, Ralph. *Stamos.* New York: Harry N. Abrams, 1974.

Steinaker, John (1927–1968), 6:97–98

Stephan, John (American, 1906–1995), 1–9 (covers); 2:45–46, 67; 3:97, 109; 4:107; 6:56; 7:33–38; 9:68

Coates, Robert M. "The Art Galleries." *The New Yorker,* October 4, 1947, pp. 77–79.

John Stephan Interviews, 1986 May 20–1987 May 7. Washington, D.C.: Archives of American Art Oral History Collection, Archives of American Art, Smithsonian Institution.

John Stephan Papers, ca. 1930s–1970s. Washington, D.C.: Archives of American Art Collection, Archives of American Art, Smithsonian Institution.

"John Walter Stephan, Abstract Expressionist, 88" *New York Times* [obituary], July 1, 1995.

"John Stephan makes his début at the Brandt Gallery…." *Art News,* July 1945, p. 7.

Solo Exhibitions:

1945: Mortimer Brandt Gallery, New York

1947, 1949, 1950: Betty Parsons Gallery, New York

Stephan, Ruth (1910–1974), 1:21–35, 93–100; 2:76, 89; 3:82–83; 6:64–65; 7:32; 8:128–38

Sterne, Hedda (American, b. Roumania, 1916–), 2:44; 9:49

Hedda Sterne: Retrospective (exh. cat.). Montclair, N.J.: Montclair Art Museum, 1977.

Hedda Sterne: Forty Years. Flushing, N.Y.: Queens Museum, 1985.

Hedda Sterne: A Painting Life (exh. broch.). New York: CDS Gallery, 1982.

Still, Clyfford (American, 1904–1980), 3:107; 6:29

Demetrion, James D., ed. *Clyfford Still: Paintings, 1944–1960* (exh. cat.). Washington, D.C.: Hirshhorn Museum and Sculpture Garden, Smithsonian Institution, 2001.

Kellein, Thomas. *Clyfford Still, 1904–1980: The Buffalo and San Francisco Collections.* Munich: Prestel, 1992.

O'Neill, John P., ed. *Clyfford Still* (exh. cat.). New York: Metropolitan Museum of Art, 1979.

Strongin, Josephine, 3:5; 7:1–2

Sweeney, John L. (deceased), 7:28–30

Swetzoff, Hyman (1919–1968), 7:5–6; 8:64–72

Sylvester, A.D.B., 6:48–51

Tamayo, Rufino (Mexican, 1899–1991), 1:61–66; 9:46

Rufino Tamayo,
New York Rooftops, 1937.
Oil on canvas, 19 ⅞ × 34 in.
Private collection
(*The Tiger's Eye* 1:64)

Genauer, Emily. *Rufino Tamayo.* New York: Harry N. Abrams, 1974.

Rufino Tamayo: Myth and Magic (exh. cat.). New York: Solomon R. Guggenheim Foundation, 1979.

Tamayo. Mexico City: Grupo Financiero Bital, Américo Arte Editores, 1998.

Tanguy, Yves (French, 1900–1955), 3:104; 6:23; 7:79

Soby, James Thrall. *Yves Tanguy* (exh. cat.). New York: Museum of Modern Art, 1955.

Von Maur, Karin. *Yves Tanguy and Surrealism.* Ostfildern-Ruit: Hatje Cantz, 2001.

Yves Tanguy: Retrospective, 1925–1955 (exh. cat.). Paris: Centre Georges Pompidou, Musée national d'art moderne, 1982.

Tanning, Dorothea (American, 1910–), 7:86

Bailly, Jean Christophe. *Dorothea Tanning.* New York: George Braziller, 1995.

Dorothea Tanning (exh. cat.). Malmö: Malmö Konsthall, 1993.

Plazy, Gilles. *Dorothea Tanning.* New York: Filipacchi Books, 1979.

Tobey, Mark (American, 1890–1976), 3:52–58; 6:27; 9:56

De Baraño, Kosme and Matthias Bärmann. *Mark Tobey* (exh. cat.). Madrid: Museo Nacional Centro de Arte Reina Sofia, 1997.

Mark Tobey Between Worlds: Works 1935–1975 (exh. cat.). Mendrisio: Museo d'arte, 1989.

Tribute to Mark Tobey (exh. cat.). Washington, D.C.: National Collection of Fine Arts, Smithsonian Institution, 1974.

Todd, Ruthven (1914–1978), 1:74–75, 93–100; 3:68–69

Tomlin, Bradley Walker (American, 1899–1953), 6:21

Baur, John I. H. *Bradley Walker Tomlin* (exh. cat.). New York: Whitney Museum of American Art, 1957.

Bradley Walker Tomlin: A Retrospective View (exh. cat.). Buffalo, N.Y.: Buffalo Fine Arts Academy, 1975.

Kramer, Hilton. "Works by Nearly Forgotten Artist in Fine Exhibit at Baruch Gallery." *New York Observer* 3, 7 (20 February, 1989), pp. 1, 12.

Toyen [Marie Cerminova] (Czechoslovakian, 1902–1980), 4:38–40 [credited as Eve Triem]

Bischof, Rita. *Toyen: Das malerische Werk.* Frankfurt: Neue Kritik, 1987.

Breton, André, Jindrich Heisler and Benjamin Péret. *Toyen.* Paris: Éditions Sokolova, 1953.

Ivsic, Radovan. *Toyen.* Paris: Éditions Filipacchi, 1974.

Tyler, Parker (1907–1974), 3:115–23

Valéry, Paul (1871–1945), 2:90–99

Valle, Carmen, 7:75

Van Hagen, Victor Wolfgang (1908–), 5:85, 92, 99–103

Vazakas, Byron (1905–), 5:3

Villa, José Garcia (1914–1997), 8:5

Virtue, Vivian L., 6:67

Wagoner, David Russell (1926–), 9:105

Wainhouse, Austryn (ca. 1925–), 4:56–63

Weathers, Winston (1926–), 6:93–96

Weber, Brom (1917–), 8 and 9, fiction consultant

Webster, Harvey Curtis (1906–), 2:49–60

Wernham, Guy, 9:20–21

Weisenthal, Morris (1920–1979), 3:6; 6:110; 9:135–40

Westphalen, Emilio Adolfo (1911–), 1:7–8

The poem from Abolition of Death *is by Emilio Adolfo Westphalen, one of Peru's leading poets and critics. He is director of the new art and literary review,* Las Moradas. *(Translated by Ruth Stephan.)* (1: 54)

Wheeler, Steve (American, 1912–1992), 8:19, 61–62

Kraskin, Sandra and Barbara Hollister. *The Indian Space Painters: Native American Sources for American Abstract Art* (exh. cat.). New York: Baruch College Gallery, 1991.

Snyder, Gary. S*teve Wheeler: A New Modernist Language* (exh. cat.). New York: Snyder Fine Art, 1994.

Steve Wheeler: Artist and Visionary (exh. cat.). New York: Richard York Gallery, 1999.

Steve Wheeler: The Oracle Visiting the Twentieth Century (exh. cat.). Montclair, N.J.: Montclair Art Museum, 1997.

Wilbur, Richard (1921–), 7:61–62

Williams, John (1922–), 5:16

… author of two books of poetry, of a prose epic of a Middlewestern Utopia, and of many articles and book reviews. She has migrated from Indiana to New York's Greenwich Village where she is writing a novel about a certain Miss MacIntosh. (1:55)

… lives near the Hudson in a remodeled schoolhouse in Palisades, New York. Her books of poetry have won many prizes, including the Pulitzer for 1937. She is writing, at present, a biography of Christina Rossetti. (1:54)

There is something sharp and demonic in the pattern of contingency and strife in the world, a dramatic energy in the unexpected, in the web of the unrhythmic. To the world of order and balance, the imponderable must be added.

Seymour Lipton,
(*The Tiger's Eye* 4:80)

Photography Credits

143

Dance You Monster to my Sweet Song

On a painting by Paul Klee

There has been time for much to fade
with photographs in velvet albums
a thumbprint blurring the date.
Take another look at the dead.

Did you imagine life would be
a matter of torques & calculations
gains & inhibitions, the clangor
of yesterday significant and clear

the forces of virtue & reason
always triumphant? Dazzle the bar
men mountebank. Nobody said your
sense of humor was defective.

Nightly you charm our past
With bracelets & with charted ways
the tall tales altered & the rest
destroyed till even the dour

Habakkuk laughs. You waste
wry wizardry & wild restraint
rouging the angels to indicate
morality loose as a goose.

Do not tell us what we know.
The fragments fall the scatological
predictions will be made where metrics
demands it. Only the innocents

have been betrayed, their fugitive
beliefs vaguely familiar, afraid
of the dead, ghosts, shadows & your
jokes of grim elaboration.

Hemstitch the rags to richer stuff
Mountebank. You are still foolish
& have mocked disorder long enough.
If the glib talk of poets survives

tomorrow & if your songs should make
you famous, remember the nature
of silence. Tell us how it feels
to fade like the others, your face

forgotten & the words malign.
Rouged, wry, inebriate & frail
tell us your services are not for sale.
Look, look at the faces of the dead.

Kenneth O. Hanson
(*The Tiger's Eye* 7:69-70)

The Children Going

To Dorothea Tanning

Ann said: If I turn my back like a leaf in the wind
Who will know I'm fleeing?
Or leave a track in the wet, wet sand
Who'll say which way I'm blowing?

Jack said: Braid your melancholy hair
And joy will comb it out
Your hair is like the sands of time
Bright with sadness, dark with delight.

Ann: The rain I'm wrapped in hides my tears
My hand is like an empty plate
Is it bad to want to be a bird
Does lightning ever strike too late?

Jack: We'll tell time by the moon
And borrow stars for buttons
And dip our feet for spoons
In clouds that bounce on the ocean.

Ann: can the cape of gold that the sun leaves
Be worn in winter weather?
My heart was deaf from the cold last year
And barely heard its own beating.

Jack: You know that summer hides in a cave
To hear the music of the frozen trees
And floods the earth with green again
Only to change the tune.

Will you take me too? Asked the boy in the boat
I've no coat, I've no shoes and the fantastic fishes
I dream of are of no use
And my boat with one oar won't get us far.

Do you sing or tell fortunes or steal or lie
Or do anything at all on the sly
Do you disobey for nothing
And dance away when called?

I do all that and more too
I can tell a man from a woman

And pain and pleasure are not the same
And even blindfolded I know my name

And blindfolded grab the world by the nose
Do you know Anywhere where the world's nose isn't?
Shall I swim or show you my stolen hours
Or teach you the nothing I didn't want to do?…

They are going, the willow whispered
Said the hunchback, Who leaps west today
May limp from the east tomorrow.
They are going, the children are going…

Ann: I'm afraid when I look in night's mirror
And do not see my face
If only the sun would wait for us
I'd never ask to sleep again.

Jack: Don't be afraid little sister
The rain goes up, the wind blows back the sun
And the river will take your tears away so far
You'll remember them as stars.

At the edge of the world there's a window
And Time stays there and gazes down
At dreams he might have dreamed had he but known!

Ann: I've dreamed enough to keep me awake forever
I've slept enough to know what it is to die.

The boat-boy: I'll take you both to a land where flowers
Are large enough to lie in, sweet enough to kill
And the warm birds bring you fishes
That plead for their lives in sounds more moving than hunger…

He returned from a land of wonders
Said the hunchback, hungry not for flowers
To roll around in, nor for the words of fishes
Nor stones to eat, but for the sound of a voice
Like his own, the sight of that miraculous mirror
Hard to replace with any other
His own reflection in another face!

Three children leaving leave the world as it was
Three seasons only and the year would not revolve
The hunchback and the willow-tree
Watch the children run, as though set free.

Charles Henri Ford
(*The Tiger's Eye* 7:87–88)

Designed by Nathan Garland
New Haven, CT
Printed by Herlin Press, Inc.
West Haven, CT